Dutch and Flemish Drawings and Watercolors

The Collections of the Detroit Institute of Arts

Dutch and Flemish Drawings and Watercolors

Anne-Marie Logan

Hudson Hills Press, New York

In Association with the Founders Society
Detroit Institute of Arts

First Edition

© 1988 by the Founders Society Detroit Institute of Arts

All rights reserved under International and Pan-American Copyright Conventions. Published in the United States by Hudson Hills Press, Inc., Suite 1308, 230 Fifth Avenue, New York, NY 10001-7704.

Distributed in the United States, its territories and possessions, Mexico, and Central and South America by Rizzoli International Publications, Inc. Distributed in the United Kingdom, Eire, Europe, Israel, and the Middle East by Phaidon Press Limited. Distributed in Australia by Bookwise International. Distributed in Japan by Yohan (Western Publications Distribution Agency).

For Hudson Hills Press
Editor and Publisher: Paul Anbinder

For the Founders Society Detroit Institute of Arts
Director of Publications: Julia Henshaw
Assistant Editor: Cynthia Jo Fogliatti

Designer: Michael Glass Design
Composition: AnzoGraphics Computer Typographers
Manufactured in Japan by Toppan Printing Company

Support for this publication was provided by the National Endowment for the Arts, the Ford Foundation, and the Founders Society Detroit Institute of Arts

Library of Congress Cataloguing-in-Publication Data

Logan, Anne-Marie S.
 Dutch and Flemish drawings and watercolors.

 (The Collections of the Detroit Institute of Arts)
 Bibliography: p. 141.
 Includes index.
 1. Drawing, Dutch—Catalogues. 2. Drawing, Flemish—Catalogues. 3. Drawing—Michigan—Detroit—Catalogues. 4. Detroit Institute of Arts—Catalogues. I. Title. II. Series: Detroit Institute of Arts. Collections of the Detroit Institute of Arts.
 NC258.L64 1987 741.9492'074'017434 87-3262
 ISBN 0-933920-85-7 (alk. paper)

Table of Contents

List of Color Plates

Foreword

The Detroit Institute of Arts has recently concluded its Centennial, celebrating 100 years of growth made possible by the generosity and support of many friends. The most significant result is a permanent collection of quality and variety, and the most appropriate means of acknowledging this achievement is to publish a series of scholarly catalogues of the collection. The first of these catalogues, *Flemish and German Paintings of the 17th Century* by Julius S. Held, was published in 1982, and the present volume joins *German Drawings and Watercolors* by Horst Uhr, published in 1987.

We are most indebted to Anne-Marie Logan, author of this catalogue, for her thorough research on each of these drawings and for her patience over the number of years from the time of her initial study of the drawings to the publication of this book. Dr. Logan is a well-known Rubens scholar. She was co-author with Egbert Haverkamp-Begemann of the section on drawings in the catalogue for the Rembrandt exhibition held in Chicago and Detroit in 1969 and of the *Catalogue of European Drawings and Watercolors in the Yale University Art Gallery, 1500-1900* (New Haven and London, 1970). The Yale collection includes 543 drawings from six volumes assembled by the Earl of Egmont in the eighteenth century. This extensive corpus, mainly of the Dutch and Flemish schools, has made Yale one of the most important centers in this country for the study of sixteenth- and seventeenth-century Netherlandish drawings. In 1979, Dr. Logan published *The "Cabinet" of the brothers Gerard and Jan Reynst* (Amsterdam/New York). She is presently head of the Library/Photo Archive at the Yale Center for British Art as well as Reviews Editor for *Master Drawings*.

Many current and former staff members of the Detroit Institute of Arts assisted with various aspects of this catalogue. Deserving special recognition are Ellen Sharp, Curator of Graphic Arts, and her staff: Christine Swenson, Associate Curator; Kathleen A. Erwin, Assistant Curator; Douglas Bulka, Senior Preparator; Diana Bulka, Preparator; Thomas Salas, Assistant to the Preparators; and Dianne Johnston, Secretary; as well as Marilyn F. Symmes, former Associate Curator; and Michael Jackson, former Assistant to the Preparators. The very important examination and conservation of each work included in this catalogue were accomplished by Barbara Heller, Chief Conservator; Valerie Baas, Paper Conservator; Elizabeth Buschor, Assistant Paper Conservator; Nancy Harris, former Paper Conservator; and Jerri R. Nelson, former Andrew Mellon Foundation Fellow.

The initial editing of the manuscript was performed by Sheila Schwartz. Final editing of the manuscript and production coordination with the publisher were supervised by Julia Henshaw, Director of Publications, who was aided by Cynthia Jo Fogliatti, Assistant Editor, and Opal D. Suddeth-Hodge, Secretary. Photography of the works was deftly handled by Dirk Bakker, Director of Photography, and his staff.

Through the efforts of Donald Jones, Assistant Director of Development, Mary Piper, Grants Coordinator, and Janet McDougal, former Development Coordinator, the museum was fortunate to receive substantial grants for research and publication of this and future permanent collections catalogues. We are greatly indebted to the National Endowment for the Arts, a Federal agency, and to the Ford Foundation, for without their encouragement and generous support, this catalogue would not have been possible.

Great appreciation is due also to Michael Glass and the staff of Michael Glass Design, Chicago, for the elegance and beauty of this catalogue. We are also grateful to Paul Anbinder, President of Hudson Hills Press, Inc., New York, for his commitment to this project.

Samuel Sachs II
Director
The Detroit Institute of Arts

Introduction

Like the Detroit Institute of Arts' collection of twentieth-century German drawings and watercolors, the group of Dutch and Flemish drawings is largely the creation of Wilhelm R. Valentiner (1880–1958), Art Advisor to the Detroit Institute of Arts from 1921 to 1923 and Director from 1924 to 1945.[1] Almost one-half of the sixteenth- and seventeenth-century Netherlandish drawings were purchased in 1934 and 1938 by Valentiner or were gifts in the 1940s and 1950s from collectors and dealers who admired and supported him.

The collection of old master drawings that existed at the museum prior to Valentiner's 1921 arrival in Detroit was small and, except for a few drawings, undistinguished. James Scripps (1835—1906), who was the founder and publisher of the *Detroit Evening News*, had given twenty-five drawings during his lifetime. Three years after his death, his widow gave the museum 1200 prints and 123 drawings, the major part of Scripps's remaining collection of graphics. There were no Dutch and Flemish drawings in Scripps's gift, but there were about twelve in that of his widow.[2] Among the Scripps drawings were three important Dutch and Flemish works: Marten de Vos's *Christ Healing the Palsied Man*, 1586 (cat. no. 58), Willem van Mieris's *Susannah and the Elders*, 1690s(?) (cat. no. 13), and Jan Goeree's *Aulus Gellius Finishing* Attic Nights, ca 1706 (cat. no. 28). The latter two drawings are exceptionally accomplished examples of their particular media. The Van Mieris utilizes black chalk on parchment to create a sensual surface in keeping with its subject, and the Goeree combines pen and brown ink with brown and gray washes to create a dramatic nocturnal ambience.

Before Valentiner became director the only other significant addition to the collection of drawings was made in 1905 by Charles L. Freer (1854–1919), a Detroit railroad industrialist, when he presented an extensive collection of graphic work by the Dutch artist Carel Nicolaas Storm van 's Gravesande. Freer's gift consisted of over 400 etchings and lithographs as well as 17 drawings and watercolors. It is to Anne-Marie Logan's credit that, despite the fact that her principal interest is in Dutch and Flemish art of the seventeenth century, she did not shirk the task of cataloguing the oft-disparaged collection of nineteenth-century work by Storm van 's Gravesande.[3] With characteristic energy and thoroughness she surveyed the entire group and related several of the drawings to the etchings. She has rightly compared Storm van 's Gravesande's watercolor style to that of his countryman Johan Barthold Jongkind. Her efforts have caused the Graphic Arts Department to look at the drawings and prints of Storm van 's Gravesande in a new light and with greater appreciation.

Wilhelm Valentiner's principal fields of interest were Italian Renaissance sculpture and painting, German Expressionist art, and Dutch seventeenth-century painting. As a young art historian he was drawn first to the art of the Netherlands. The subject of his doctoral dissertation at the University of Heidelberg was the great Dutch artist Rembrandt.[4] In that same year he was hired by the Dutch art historian Cornelis Hofstede de Groot to assist in the preparation of the first complete catalogue of Rembrandt drawings and of a catalogue of Dutch seventeenth-century painters. Valentiner worked for a year in The Hague on these projects and, during that time, visited other major cities as well as almost every village in the north and south of Holland. On these excursions he developed a sensitivity to the special character of the Dutch landscape with its broad, flat expanses of land and windmills and towns silhouetted against a low horizon. He came to appreciate the quality of light in each area and to sympathize with the robust life of the common people. He realized how superbly these aspects of their country were captured by the artists of the Netherlands.

In 1906 Valentiner was invited to come to Berlin by Wilhelm von Bode, Director of the Kaiser-Friedrich-Museum and the most influential art historian in Europe. Under Bode's leadership the museums of Berlin had become the center of the European art world. Valentiner considered the period that he spent working with Bode as the most decisive in his career. During the two years that he was associated with Bode, he had the opportunity to work in several curatorial departments of the

museum, including decorative arts, Islamic art, with Max J. Friedländer in paintings, and with Max Lehrs in the Print Room. His publications while in Berlin included works on Rembrandt and on the drawings of the early Dutch genre painters. In 1908 Bode recommended Valentiner to the trustees of the Metropolitan Museum in New York, where Valentiner was appointed Curator of Decorative Arts. While in New York he organized an exhibition of the paintings of Dutch masters for the Metropolitan. After World War I, upon his return to the United States in 1921, he continued to publish and organize important exhibitions of Dutch and Flemish art, in many cases the first exhibitions of such scope and scholarly importance to be shown in museums in this country. After he became director of the Detroit Institute of Arts in 1924, Valentiner presented several major loan exhibitions of Dutch and Flemish art until his retirement in 1945.

In the summer of 1934, with letters of credit totaling $4,000, Valentiner went to Europe and acquired from a variety of sources a group of sixty-nine drawings ranging from the sixteenth to the nineteenth century, including many of the most celebrated artists of the Italian, French, Dutch, and Flemish schools. The story of this purchase is a legendary one in the museum world, especially in this era of dramatically escalating prices for old master drawings.[5] After deducting his modest travel expenses, Valentiner returned about $100 to the museum. Twenty-two of the sixty-nine drawings were by Dutch and Flemish artists. Although Anne-Marie Logan, through her extensive research for this catalogue, has determined that some of Valentiner's attributions cannot be upheld in the light of contemporary scholarship, there still remain many remarkable acquisitions among this group by less well-known Dutch and Flemish artists. Highlights of the 1934 purchases include an early sixteenth-century drawing by the Flemish artist David Joris, *Christ Giving the Keys to Saint Peter*, ca. 1524–29 (cat. no. 56); two studies by Abraham Bloemaert depicting saintly hermits in which color washes and white heightening combine with fine strokes of the pen and brown ink to create images imbued with life and charm (cat. nos. 1 and 2); a brush drawing by Bartholomeus Breenburgh in rich shades of brown that depicts a Roman landscape (cat. no. 5); and the study *Head of a Boy* (cat. no. 21) by Gerard Terborch the Younger, with its remarkably delicate use of pen and brown ink with gray wash, demonstrating the artist's prodigious talent at the age of sixteen to eighteen. In 1938 Valentiner made some fine additional purchases, including the striking sheet with astutely observed studies of heads by Jacques de Gheyn II (cat. no. 7), a rare, early landscape drawing by Jan van Goyen (cat. no. 6), a lively, loose sketch of peasants by Philips Koninck (cat. no. 10), and an imaginary landscape by Roelant Roghman (cat. no. 17).

Valentiner's experience as a young man serving under Bode in various departments of the Kaiser-Friedrich-Museum shaped many of his policies throughout his museum career. The collections he assembled for Detroit have much the same character as those in the Berlin-Dahlem Museum today.[6] Several of the drawings he acquired for the Detroit Institute of Arts in 1934 are related to similar drawings in the Berlin Print Room as, for example, *Landscape with Shepherds* by Jan van Huysum (cat. no. 30) and the afore-mentioned *Christ Giving the Keys to Saint Peter* by David Joris. In a report to Clyde H. Burroughs, Administrator of the Detroit museum, concerning his 1934 purchases, Valentiner made several references to the Berlin Print Room. He seems to have consulted several curators there concerning the attributions of some of the works. In a postscript to the report he made special note of the drawing by Joris as being of considerable importance.[7] Valentiner also noted to Burroughs that he felt he had acquired a remarkable selection of drawings of different periods. An exhibition of these works was presented at the Detroit Institute of Arts in 1936, and the small catalogue written by Ernst Scheyer was the first and only critical catalogue of the drawings in Detroit until the present series.[8] Valentiner, who knew of Ernst Scheyer through his articles in

European scholarly journals, brought Scheyer to Detroit in 1936 and assigned as his first task the preparation of the catalogue.

Several intriguing questions come to mind when considering Valentiner's drawing acquisitions for Detroit. Why did he not purchase a drawing by the greatest and most original of the Dutch draftsmen, Rembrandt van Rijn? A drawing by the Flemish master Rubens is also lacking. Valentiner realized that the so-called Rubens drawings in the Scripps collection (cat. nos. A19, A20, and A21) were not by this artist's hand. Yet among his 1934 purchases there was only a School of Rubens work that Anne-Marie Logan now has catalogued as by an unknown Flemish artist (cat. no. A22). A further significant lacuna in the Detroit collection is a drawing by Vincent van Gogh. In his "Reminiscences," covering the years 1890 to 1920, Valentiner describes his activities in 1905 when he was working in Holland and his discovery of the genius, "the fiery glow," of Vincent van Gogh.[9] He found some Van Gogh drawings in an antique shop and bought one for himself.[10] He was unable, however, to interest collectors or museums in acquiring any such drawings. During his tenure as director in Detroit, Valentiner obtained superb paintings by Breughel, Rubens, Rembrandt, and Van Gogh but no drawings by these artists. Undoubtedly most of his energies (and the purchase funds available) had to be concentrated on building the painting and sculpture collection. As for encouraging local collectors to purchase works (many of which eventually would be given or bequeathed to the museum), Valentiner focused his attention on the works of twentieth-century German artists. He had great success in interesting Detroit collectors in the work of the German Expressionists, such as Ernst Ludwig Kirchner, Emil Nolde, and Karl Schmidt-Rottluff, especially when we take into account that these artists were some of the most avant-garde of that time.[11]

After Valentiner retired in 1945, there were few acquisitions in the area of Dutch and Flemish drawings. Under the directorship of Edgar P. Richardson from 1945 to 1962, emphasis was placed on American art of the eighteenth to the early twentieth centuries. However, when Paul L. Grigaut served as Chief Curator from 1955 to 1962, he acquired two important and beautiful drawings. One is a little-heralded masterpiece—Joachim Wtewael's *Suffer the Little Children to Come unto Me*, ca. 1621 (cat. no. 25), which Wolfgang Stechow identified as a preliminary study for Wtewael's signed painting in Leningrad. The other, *Apollo Enthroned with Minerva and the Muses* (cat. no. 33), by Jacob de Wit, is a ceiling design made in 1730 for the house of a wealthy merchant in Amsterdam.

In the years since 1965, when the Detroit museum received the John S. Newberry Bequest with its splendid representation of drawings and watercolors by nineteenth- and early twentieth-century French artists, we have most often used our limited purchase funds to enrich the drawing collection in the field of nineteenth-century French art. We did acquire, in 1971 from the estate of Paul L. Grigaut, a rare landscape drawing (cat. no. 27) by the little-known Dutch artist A. Erkelens, who was active around 1800 and worked in color washes with pen and brown ink in the manner of certain Dutch seventeenth-century landscape artists. The Erkelens makes an interesting addition to the group of landscape drawings assembled by Valentiner.

Our most recent purchase, a flower piece by Jan van Huysum (cat. no. 29), pays homage to Wilhelm Valentiner and his interest in the field of Dutch and Flemish drawings. Jan van Huysum is known to have made two types of drawings—baroque flower arrangements in watercolor and black chalk and classical landscapes executed with a fine pen. His *Flowers in an Urn on a Plinth*, ca. 1730s, a sumptuous grisaille-like drawing in brown and white gouache over black chalk, complements *Landscape with Shepherds*, a part of Valentiner's memorable purchase of 1934.

Ellen Sharp
Curator of Graphic Arts

Notes

1.
See Introduction in Horst Uhr, *German Drawings and Watercolors including Austrian and Swiss Works, the Collections of the Detroit Institute of Arts*, Hudson Hills Press, Inc., New York, 1987.

2.
A definite number is difficult to give here without a lengthy discussion of the reattributions that have been made over the years. Annotations in Scripps's manuscript catalogue indicate Valentiner reattributed two drawings previously given to Rubens: *A Cavalry Charge* (09.1S–Dr.225) has been reattributed to an early nineteenth-century English artist; *Abraham's Sacrifice* (09.1S–Dr.226) is now attributed to a French artist. From our drawings formerly catalogued as Italian, Anne-Marie Logan has shown a drawing previously given to Cavalier d'Arpino to be a copy after Jan de Bisschop (cat. no. A2). A drawing attributed to Annibale Carracci is here catalogued as a copy after Marten de Vos (cat. no. A15). In 1956 Mrs. William E. Scripps gave two drawings that had belonged to her father-in-law, one a copy after Adriaen van Ostade (cat. no. A8) and the other by an unknown Dutch artist (A10).

3.
Freer, of course, is most well known for his collections of Asian art and of works by James McNeill Whistler that he presented to the Smithsonian Institution and that are now housed in the Freer Gallery of Art, Washington, D.C. Unfortunately for Detroit, Freer never considered giving these superb collections to the city where he made his fortune and maintained his principal residence. See Helen Nebeker Tomlinson, *Charles Lang Freer, Pioneer Collector of Asian Art*, 4 vols., unpub. diss., Case Western Reserve University, 1979, and Thomas W. Brunk, "A Note on Charles Lang Freer," *BDIA* 59, no. 1 (1981): 17–23. Ms. Tomlinson dispels the traditionally held belief in Detroit art circles that in giving the Detroit Institute of Arts a comprehensive collection of works by an obscure Dutch printmaker, Freer was showing his disdain for the museum. Freer was introduced to the work of Storm van 's Gravesande by Frederick Keppel. He admired and collected the Dutch artist's work to the same depth as he did Whistler's etchings and lithographs. As Freer prepared his gift of Whistler's work and of Asian art to the nation, he made careful disposition of his print collection to various museums, colleges, and universities. I am grateful to Linda Merrill at the Freer Gallery of Art for drawing my attention to Ms. Tomlinson's thesis and for other information on Freer.

4.
Wilhelm R. Valentiner, *Rembrandt und seine Umgebung* (Rembrandt and his Environment), J. H. E. Hertz, Strasbourg, 1905.

5.
See Margaret Sterne, *The Passionate Eye: The Life of William R. Valentiner*, Wayne State University Press, Detroit, 1980, pp. 249–250, for a list of the drawings and the price paid for each.

6.
After World War II, the Berlin collections were divided between East and West Berlin. Today, most of the West Berlin collections are situated in the Dahlem section of the city.

7.
See Sterne, p. 221.

8.
Ernst Scheyer, *Drawings and Miniatures from the XII. to the XX. Century*, the Detroit Institute of Arts, 1936. A copy of this catalogue with later annotations by Scheyer is in the files of the Department of Graphic Arts. Ernst Scheyer told this author that Valentiner was most positive about the attributions of the drawings and would not consider any changes Scheyer proposed.

9.
The bulk of Valentiner's papers, including "Reminiscences," diaries, notes, unpublished manuscripts, correspondence, etc., is in the archives of the North Carolina Museum of Art. See Sterne, pp. 66–67.

10.
Valentiner left the drawing in storage at the Metropolitan Museum of Art during World War I; it has since disappeared. See Sterne, pp. 66–67.

11.
See Sterne, pp. 128, 141–149, 234, 245–246, and 352.

Author's Acknowledgments

The basic research for this catalogue was carried out in 1977 at the Rijksbureau voor Kunsthistorische Documentatie in The Hague, and the manuscript was submitted in January 1980. Since that time updated information has been incorporated as much as possible.

Many people aided me in my research for this catalogue. I am grateful to Egbert Haverkamp-Begemann for his valuable suggestions and references. Dr. An Zwollo and Dr. George Keyes also made helpful comments regarding the attributions of several drawings. Others who assisted me in questions of attribution are acknowledged in the catalogue entries. Most appreciated was the constructive criticism I received from Julius S. Held, who carefully read the manuscript and made some welcome improvements.

At the Detroit Institute of Arts I would particularly like to thank Ellen Sharp, Curator of Graphic Arts, and her staff: Christine Swenson, Associate Curator; Kathleen A. Erwin, Assistant Curator; and Marilyn F. Symmes, former Associate Curator. For their help in seeing this manuscript through its various stages I would like to thank Julia Henshaw, Director, and Cynthia Jo Fogliatti, Assistant Editor, Publications Department.

Anne-Marie Logan
New Haven, 1987

Notes to the Catalogue

SEQUENCE

Within the categories of Dutch and Flemish works, the catalogue entries are arranged chronologically by century and then alphabetically by the artist's surname (for example, Dyck rather than Van Dyck, Wit rather than De Wit) or by the designation "Unknown Dutch" or "Unknown Flemish" when the artist is not known. When two or more works by the same artist are listed, they are given in chronological order. Several minor works have been grouped in an Appendix following the main catalogue.

ATTRIBUTION

Works either signed or considered to be autograph are designated by the artist's name. If a reasonable doubt exists concerning the authorship of a work, the term "attributed to" has been used. The following terms are defined to clarify an artist's contribution to works not believed to be autograph:

"Circle of": the drawing is the work of an unidentified artist who is stylistically related to the master, possibly trained or directly influenced by him, and proximate in time and place.

"Style of": the drawing is similar stylistically to the work of the master, but direct influence may be lacking; this phrase implies a distance in time and/or place from the master.

"Copy after": the drawing is a copy, by an unidentified artist, of a known or suspected original by the master but not produced in his studio; a copy may range in date from a work contemporary with the original to a modern version.

"Imitator of": the drawing is the work of an unidentified artist who deliberately intended that it pass as an original by the master; the forgery may be contemporary with works by the master or may be of later invention.

MEDIUM AND CONDITION

Although most terms used in the description of media and condition are self-explanatory, a few require clarification. The terms *graphite* and *graphite pencil* are used in this catalogue to distinguish methods and techniques of application rather than elemental differences. Graphite refers to the use of the material in lump or stick form, producing lines of variable thickness. Graphite pencils are fabricated by mixing powdered graphite with clay, and occasionally other materials, forming the mixture into rods, and mounting the rods in hollow wooden sheaths. Graphite pencils produce a thinner, more consistent line than graphite in its pure form. The medium of graphite, whether natural or synthetic, in stick or pencil form, is a grayish black, semi-crystalline, flaky, and greasy material that, when applied to paper, has a characteristic metallic sheen.

White lead discoloration or blackening is a chemical change that occurs when the medium (basic lead carbonate) is exposed to hydrogen sulfide present in the atmosphere and is converted to black sulphide. The chemical process generally may be reversed with simple treatment.

Condition descriptions were prepared by Nancy Harris, former Paper Conservator, and by Valerie Baas, Paper Conservator.

DIMENSIONS

Dimensions have been given for all works, height preceding width. Measurements were taken at the time each drawing or watercolor was examined by Detroit Institute of Arts conservators.

PROVENANCE

The history of each work has been traced as completely as possible. References to collector's marks,

estate stamps, etc., in Lugt (see bibliography) are given as L. or L. Suppl. In the case of sales, the owner's name, if known, precedes the place and date of the sale. The phrase "offered for sale" indicates that the drawing was not sold at that time.

EXHIBITIONS AND REFERENCES

All known exhibition and bibliographical information has been included, with the exception of references to illustrations that convey no information about a work (such as in annual reports, picture books, etc., published by the Detroit Institute of Arts and others). References to sales catalogues are listed under provenance.

Within the entries, exhibition and bibliographical references are indicated by a short form consisting of the city and date of exhibition for the former and the author's name and date of publication for the latter. Complete citations may be found in the bibliography.

ACCESSION NUMBERS

In this catalogue the full year of acquisition is given in each accession number even though the first two digits of the year of acquisition were not used in accession numbers prior to 1983, at which time it became necessary to use the complete year to distinguish between works acquired in 1883 and those acquired in 1983 and later years. Therefore, in museum records, numbers such as 1934.92 are listed as 34.92.

ABBREVIATIONS

Only two abbreviations have been used in this catalogue. In the text RKD signifies the Rijksbureau voor Kunsthistorische Documentatie, The Hague, and in the references and bibliography *BDIA* signifies the *Bulletin of the Detroit Institute of Arts.*

Dutch Drawings and Watercolors

Abraham Bloemaert

1564 Dordrecht – Utrecht 1651

1.
Saintly Hermit, ca. 1612

Pen and brown ink and greenish blue wash over a
preliminary drawing in black chalk, heightened
with white, on buff laid paper; 142 x 109 mm

INSCRIPTION: Signed with pen and brown ink on
recto at lower left, *A. Bloemaert.fe.*

ANNOTATIONS: With pencil on verso in center, *a/1*
[in circle]; with pencil on verso in lower left corner,
[indecipherable]; with pencil on verso at lower
center, *Nº 283*

WATERMARK: Crozier of Basel (cf. Heawood 1189)

CONDITION: Foxing and slight cockling at edges

PROVENANCE: E. Speelman, London

REFERENCES: *BDIA* 1935: 57; Scheyer 1936,
no. 71

Founders Society Purchase, William H. Murphy
Fund (1934.92)

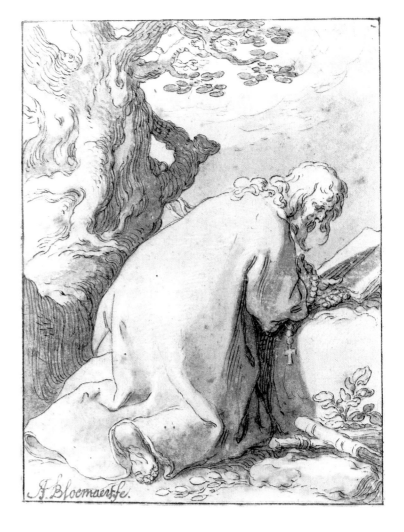

2.
Saintly Hermit, Walking on Water, ca. 1612

Plate I

Pen and brown ink and greenish brown wash over a
preliminary drawing in black chalk, heightened
with white, on buff laid paper; 139 x 111 mm

ANNOTATIONS: With pencil on verso in center, *b/1*
[in circle]; with pencil on verso at lower left, *N*
[indecipherable] *6*; with pencil on verso at lower cen-
ter, *Nº 283*; with pencil on verso at lower right,
Bloemaert

CONDITION: Foxing; white lead discoloration; slight
cockling

PROVENANCE: E. Speelman, London

REFERENCES: *BDIA* 1935: 57; Scheyer 1936, no. 73

Founders Society Purchase, William H. Murphy
Fund (1934.93)

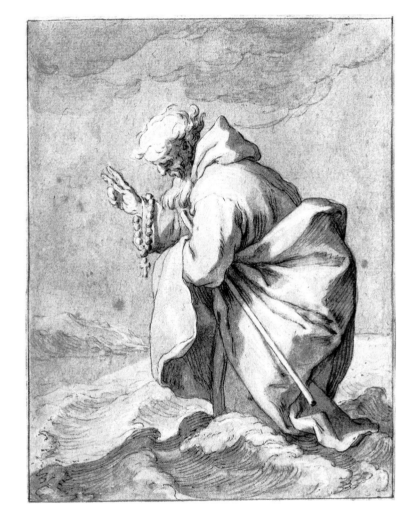

Both drawings may have been intended for the *Silva
anachoretica...Ad sacrum speculum* of 1612, the
series of twenty-four plates representing saintly
hermits engraved and published by Boetius à
Bolswert (1580–1633) (Hollstein 1949–, 2: 66, nos.
355–378; and 3: 63, nos. 96–119). The series also
appeared in woodcut. No prints after these two
sheets are known. Additional Abraham Bloemaert
drawings of pious hermits, for which there are no
engravings, are found in Amsterdam (Amsterdam
1978, nos. 39, 41).

The two drawings in Detroit closely relate in
execution to the few extant preliminary studies by
Bloemaert for Bolswert's engravings, for example,
the ones in Amsterdam (Amsterdam 1978, no. 40),
Berlin (Bock and Rosenberg 1930, 1: nos. 267–270),
and the Albertina (Vienna 1928, nos. 424–427). This
further supports the supposition that the drawings
originated at the same time and thus date from
ca. 1612.

Another version by Bloemaert of the hermit
walking on the water is in the De Grez collection,
Brussels (cat. 1913, no. 350).

Circle of
Abraham Bloemaert

3.
Soldiers Resting, ca. 1630–50

Pen and brown ink and gray wash over a preliminary drawing in graphite on discolored laid paper; 141 x 199 mm

ANNOTATION: With pencil on verso at lower right, *D 1207* [in circle]

WATERMARK: Arms of the Seven Provinces: lion, sword, and seven darts in the crowned shield (cf. Churchill 118)

CONDITION: Discoloration; some foxing

PROVENANCE: E. Parsons & Sons, London

REFERENCES: *BDIA* 1935: 57; Scheyer 1936, no. 77 (as *Sleeping Soldiers*)

Founders Society Purchase, Octavia W. Bates Fund (1934.91)

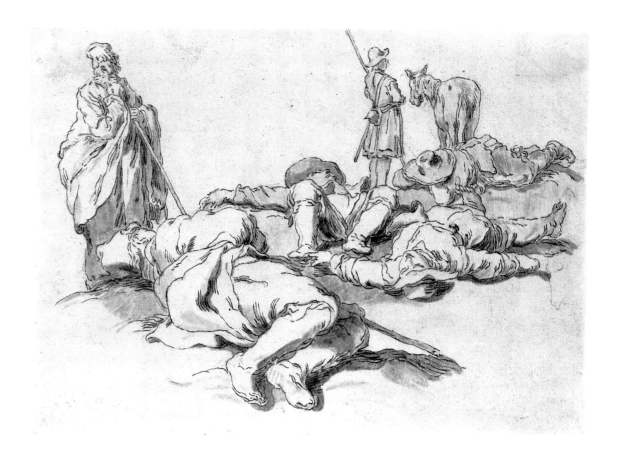

Five of the figures in this drawing are taken from four separate sheets by Abraham Bloemaert that once were part of a sketchbook of more than forty sheets, now dispersed primarily between Amsterdam (see Amsterdam 1978, no. 62) and the Fitzwilliam Museum, Cambridge. The reclining figure in the foreground appears in the same pose in a drawing in the British Museum of *The Annunciation to the Shepherds* (London 1915–32, 5: 91 and pl. 38) and also, although without a staff, at top right on the verso of a drawing in Amsterdam that represents *Two Seated Women, One of Whom is Reading, a*

Reclining Boy, and Two Tree Stumps (fig. 1; ibid, no. 60v). The standing figure at the left, resting on a staff, is based on a similar figure in another sheet by Bloemaert in Amsterdam (fig. 2; ibid., no. 61). The guard seen from the back at the upper right is adopted from a figure in the center of Bloemaert's drawing in Amsterdam of a *Seated Old Man and Other Figures* (ibid., no. 56). That same sheet also includes the youth sprawled on his back with his head toward the spectator, a figure that recurs in the Detroit drawing, but stretched out in the opposite direction with the legs pointing to the right. The

youth in the upper right, lying on his stomach, is found in mirror image on the verso of a drawing in the Fitzwilliam Museum (inv. PD 156–1963v). Additional figure studies from Bloemaert's sketchbooks are known today primarily through a series of etchings by François Boucher (1703–1770), published in the *Livre d'Etude d'Après les Desseins Originaux de Blomart...*, Paris, 1735 (Slatkin 1976, pp. 247–260).

The various figures in the Detroit drawing are copied almost entirely from the prototypes by Bloemaert in Amsterdam and Cambridge and are re-grouped into a different, more compact configuration. The draftsman, therefore, must have had access to the sketchbook while it was still intact. Although certain figures, in particular the man leaning on his staff at the left, are rendered in a rather ill-defined manner, the drawing may nevertheless have originated in the Bloemaert circle. The drawings from the sketchbook that are now in Amsterdam are slightly larger than the Detroit drawing, most were executed in black chalk and were strengthened with pen and brown ink, and, according to Boon (Amsterdam 1978) date from the late 1620s, since related figures appear in two signed Bloemaert paintings dated 1632 in Utrecht. The Detroit drawing, therefore, dates from after 1630.

The author would like to thank Dr. Jacob Bolten, Prentenkabinet, Leiden, for the information he provided about these three drawings in a letter of August 3, 1977.

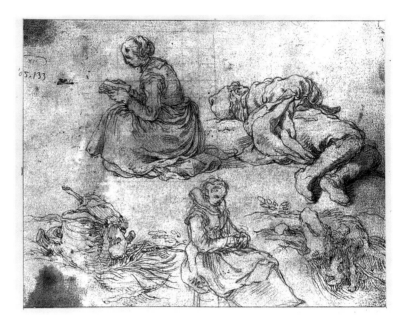

Fig. 1.
Abraham Bloemaert. *Two Seated Women, One of Whom is Reading, a Reclining Boy, and Two Tree Stumps*, late 1620s. Pen and brown ink over black chalk, 168 x 221 mm. Rijksmuseum, Prentenkabinet, Amsterdam (inv. 05:133 verso). Photo: Rijksmuseum.

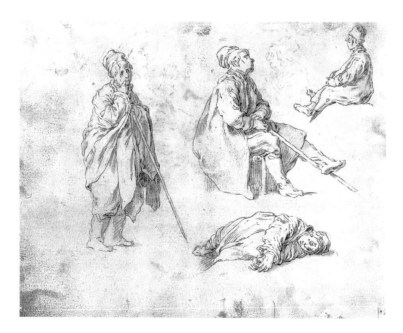

Fig. 2.
Abraham Bloemaert. *Seated and Standing Boy with Stick, a Boy Lying Down, and One Seated in Profile*, late 1620s. Pen and brown ink over black chalk, 165 x 218 mm. Rijksmuseum, Prentenkabinet, Amsterdam (inv. 05:134 recto). Photo: Rijksmuseum.

Leonard Bramer

1596 Delft 1674

4.

The Denial of Saint Peter (recto)
Mary Magdalen at the Tomb of Christ
(verso)

Brush and black ink and gray and black wash, heightened and corrected with white, on tan laid paper; 222 x 164 mm

CONDITION: White highlights on the two sides are not identical: white on recto appears to be lead white but that on verso has characteristic ultraviolet fluorescence of zinc white, which was not in use until the nineteenth century. Faint horizontal creasing; abrasion at edges; trimmed on all four sides with loss to image on verso

PROVENANCE: J. Goudstikker, Amsterdam

REFERENCES: *BDIA* 1935: 57; Scheyer 1936, no. 87, ill.

Founders Society Purchase, William H. Murphy Fund (1934.94)

This is a rather typical drawing by Bramer drawn freely with a wide brush on coarse paper. Both the recto with Saint Peter's denial of Christ and the verso with Mary Magdalen's visit to the empty tomb of Christ may be part of a series illustrating the life of either Christ or Saint Peter.

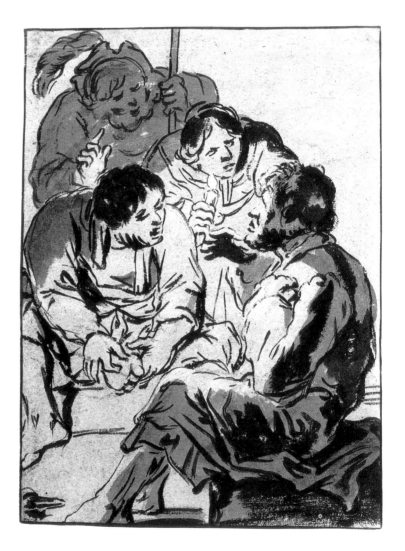

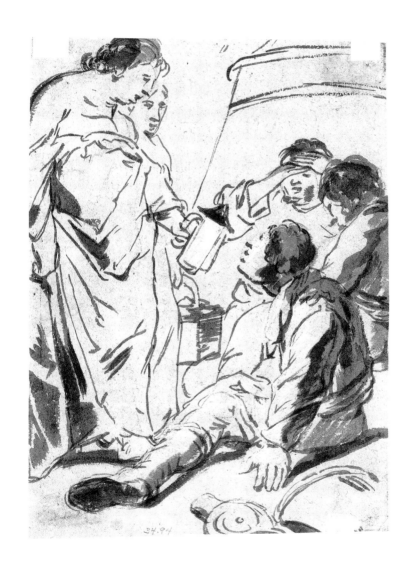

Bartholomeus Breenbergh

1598/1600 Deventer – Amsterdam 1657

5.

Italian Village on a River, ca. 1627

Plate II

Pen and brush and dark brown ink and brown wash over a preliminary drawing in graphite on white laid paper; 317 x 502 mm

ANNOTATIONS: With pencil on verso in center, *Jan de Bisschop / 1640–1686*; with pencil on verso in lower right corner, *0.1727* [in circle]

WATERMARKS: Anchor and figure in shield (cf. Heawood 1346–1354)

CONDITION: Vertical join at center of sheet reinforced on verso; vertical fold left side; extensive foxing; abrasion at edges; loss at bottom left; scattered white accretions at upper right

PROVENANCE: E. Parsons & Sons, London

REFERENCES: Scheyer 1936, no. 86 (as Jan de Bisschop); Röthlisberger 1969, under no. 98

Founders Society Purchase, Octavia W. Bates Fund (1934.90)

The reattribution of this drawing from Jan de Bisschop (1628–1671) to Breenbergh was made by Frits Lugt (note, 1941; Curatorial Files). This view of a village nestled against a hillside probably records a location in the environs of Rome. As is customary with Breenbergh, it is a finished drawing, made without a painting in mind. Since the view extends over two sheets of paper, the drawing may once have been part of a sketchbook. The drawing relates to studies by Breenbergh of ca. 1627, such as the *View of Tivoli* in the Metropolitan Museum of Art (inv. 1962.63.2), and most likely dates from the same time. As Julius S. Held observed (verbally), it bears a close similarity to drawings of Roman views by the Haarlem Italianist Willem Romeijn (ca. 1624–1695; see Knab 1964, pp. 163–168).

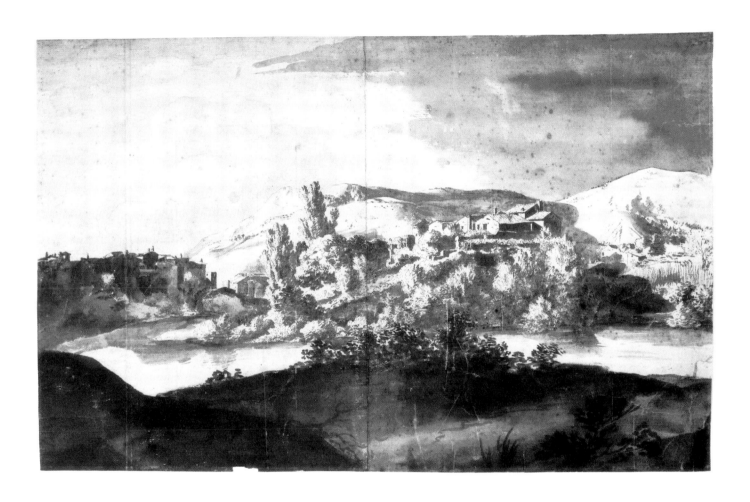

Jacob van der Does the Elder

1623 Amsterdam – Sloten 1673

6.
Seated Boy

Black chalk on buff laid paper; 190 x 258 mm

ANNOTATIONS: With pencil on verso at lower left, *D 1350* [in circle]; with pencil on verso in center, *Jacob van der Does. / B. 1654. / D. 1691. / From the Spengler Collection* [indecipherable] / *No 285*

WATERMARK: Arms of Amsterdam (cf. Churchill 1–78)

CONDITION: Accretion near center; light creasing

PROVENANCE: J. C. Spengler, Copenhagen (brown collector's mark [L. 1434] on recto at center); E. Parsons & Sons, London, sales cat. 46, no. 267, ill., and sales cat. 50, no. 325, ca. 1928

REFERENCES: *BDIA* 1935: 57; Scheyer 1936, no. 81

Founders Society Purchase, Octavia W. Bates Fund (1934.104)

The traditional attribution to this little-known draftsman is retained here for lack of a better alternative. The drawing may have been made by an eighteenth-century artist, as the hat worn by the boy seems a later style.

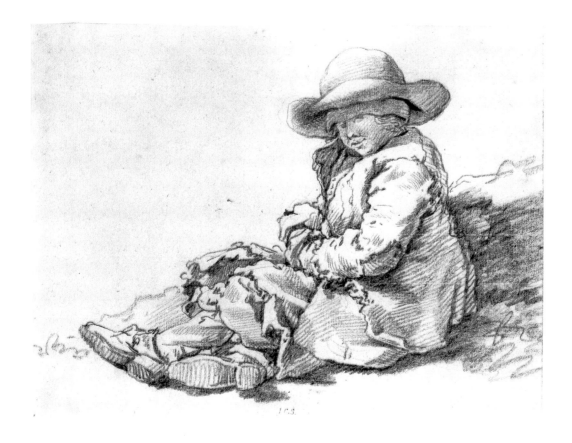

26

Jacques de Gheyn II

1565 Antwerp – The Hague 1629

7.

*Studies of the Heads of Two Youths and an
Old Woman*, ca. 1600–1605

Pen and dark brown ink over graphite on laid paper
toned with graphite; 132 x 97 mm

ANNOTATIONS: With pencil on verso at upper edge,
[indecipherable, cut off]; with pen and brown ink on
verso at lower center, *Jacq: de Gheyn.f / 5.6d* [by C.
Ploos van Amstel, cut off]; on verso in lower left
corner, [indecipherable]

CONDITION: Trimmed on all four sides; upper left
corner reattached; repaired tears in bottom corners;
scattered minor edge tears; water stain lower left
corner

PROVENANCE: C. Ploos van Amstel, Amsterdam (L.
3003, 3004); E. Joseph-Rignault, Paris (black collec-
tor's mark [L. 2218] on recto at upper right, *Rig* [cut
off]); Dr. Aram, New York

REFERENCES: *BDIA* 1939: 11; Richardson 1940, p. 63,
fig. 11; Van Regteren Altena 1983, no. 738, pl. 399

City of Detroit Purchase (1938.9)

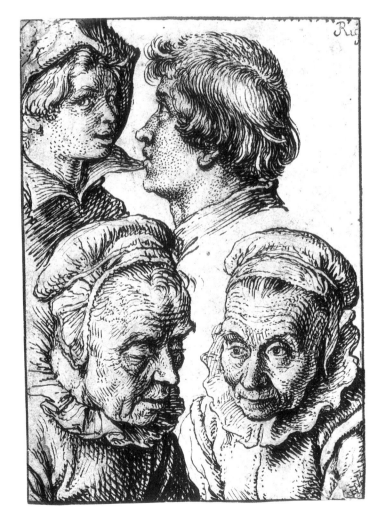

The astute observation of the individual heads suggests that Jacques de Gheyn II drew these faces from life, most likely for reuse in larger compositional drawings or in paintings. Thus, as J. Q. Van Regteren Altena verbally pointed out, the boy at top left is related to the youth at the left in De Gheyn's signed *Fortune-Teller* in the Herzog Anton Ulrich-Museum, Brunswick (Judson 1973, fig. 104). This boy in turn seems to be based directly on the full-length youth in De Gheyn's *Three Gypsies* in the Art Institute of Chicago (ibid., fig. 105). Similar old women that represent hags or witches are found in a number of drawings by De Gheyn.

At least four other pen drawings by Jacques de Gheyn II of almost identical dimensions are known, each depicting three or four separate studies of heads: *Three Hags* (138 x 97 mm; ibid., fig. 97) and the *Study of Four Heads* (147 x 96 mm; ibid., fig. 100), both in the Teyler Foundation, Haarlem; *Three Studies of a Youth's Head* in the collection of George and Maida Abrams, Newton, Massachusetts (140 x 95 mm; Hanover and Hartford 1973, no. 10); an *Old Man and Two Women* (private collection, Amsterdam, originally from the Cornelis Ploos van Amstel collection, 141 x 95 mm; Amsterdam 1935, no. 44, fig. 2). A number of additional such drawings exist, all representing two to four individual heads combined on a small sheet. The Detroit drawing appears to have been clipped at the left and thus may be a fragment of a larger drawing, such as the *Study of Nine Heads* in Berlin, signed and dated *1604* (Judson 1973, fig. 81).

In execution, the drawing closely resembles the *Portrait of a Man Half-Length* in Amsterdam, which Boon associates with fishermen De Gheyn drew in Scheveningen in 1603 (Amsterdam 1978, no. 217, ill.), and where we find the same dense hatching as well as the application of small dots to indicate modeling in the face. The drawing, therefore, probably also dates from the early years of the seventeenth century.

The attribution of the Detroit drawing to Jacques de Gheyn II was questioned by Lugt in an annotation on the photo at the Rijksbureau voor Kunsthistorische Documentatie (RKD), The Hague. Lugt thought that the sheet might be by De Gheyn's son, Jacques III, also known as De Gheyn the Younger. In that case, the son would have copied his father's drawings, a suggestion that J. Q. van Regteren Altena rejects in favor of an attribution to Jacques II (letter to the author, November 15, 1979). According to Julius S. Held (verbally), the drawing can only be a copy.

The Detroit drawing once belonged to Cornelis Ploos van Amstel (1726–1798), who left one of the largest collections of Dutch seventeenth-century drawings and prints, among them more than 80 studies by Rembrandt, 39 landscape drawings by Lambert Doomer (1624–1700), and 240 large views of castles by Roelant Roghman (see cat. no. 17), together with 325 sheets by Jan de Beyer (see cat. no. 26).

Jan van Goyen

1596 Leiden – The Hague 1656

8.

Landscape with Figures, 1631

Black chalk and gray wash on buff laid paper;
112 x 189 mm

INSCRIPTION: Signed and dated with black chalk on
recto at lower left, *V G 1631*

ANNOTATION: With pencil on verso at center, *994*
[in circle]

WATERMARK: Tulip in a vase

CONDITION: Slight foxing; vertical fold at center

PROVENANCE: Unidentified collector's mark on
verso at lower left; Count A. Thibaudeau, Paris, sale,
April 20, 1857, no. 341; Louis Deglatigny, Rouen (red
collector's mark [L. Suppl. 1768a] on recto at lower

right), sale, Jean Charpentier, Paris, May 28, 1937, no.
45 (purchased by Otto Wertheimer, Paris); Paul
Wescher, Berlin

REFERENCES: *BDIA* 1939: 11; Richardson 1939, p. 15,
fig. 2; Beck 1972–73, p. 33, no. 96, ill.

Founders Society Purchase, William H. Murphy
Fund (1938.19)

Only a few Van Goyen drawings from 1631 are
known. The Detroit sheet is one of his early draw-
ings in black chalk, a medium he preferred from
1626 onward. The composition does not recur in a
painting.

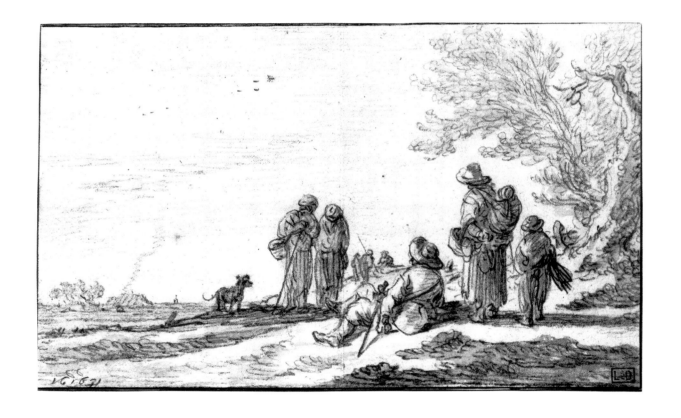

9.
Dune Landscape with Figures, 1653

Black chalk and gray wash on buff laid paper;
113 x 194 mm

INSCRIPTION: Signed and dated with black chalk on
recto at lower right, *VG 1653*

ANNOTATIONS: With pen and brown ink on recto at
lower left, *286.*; with pencil on verso at center, *286*
[twice]; with blue chalk on verso in center, *30*; with
pencil on verso at lower left edge, *40620* [inde-
cipherable, cut off]

CONDITION: A few creases

PROVENANCE: E. Speelman, London

REFERENCES: *BDIA* 1935: 57; Scheyer 1936, no. 80;
Richardson 1939, p. 16, fig. 3; *Art News* 1939: 14, ill.;
Beck 1972–73, no. 413, ill.

Founders Society Purchase, William H. Murphy
Fund (1934.105)

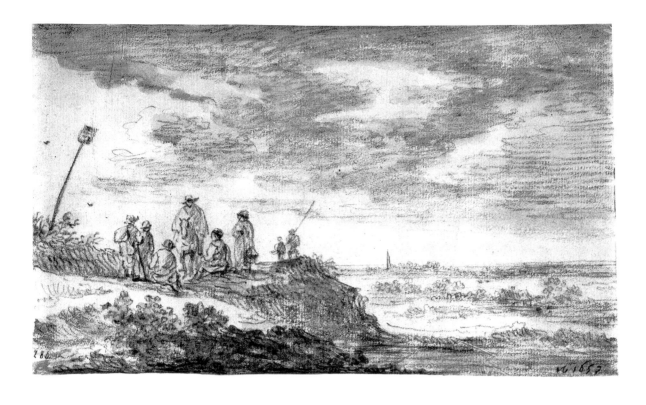

The year 1653 was very productive for Van Goyen;
almost three hundred drawings of that date survive
(see also cat. no. A6). Van Goyen used the same com-
position a number of times—people gathered at the
left near a signal and an open space at the right. Most
closely related are drawings in the P. J. Snijders col-
lection in Johannesburg (from the Hofstede de Groot
collection, sale, Boerner, Leipzig, November 4, 1931,
no. 102) and in the Veste Coburg (Coburg 1970, no. 4,
fig. 59), both signed and dated 1653. Neither of these
two, nor the Detroit drawing, was used by Van
Goyen for any of his paintings.

Philips Koninck

1619 Amsterdam 1688

10.
Peasants in a Tavern, ca. 1662

Pen and brush and brown ink and brown and gray wash on buff laid paper; 147 x 205 mm

ANNOTATIONS: With pencil on verso at lower center, *A. Brouwer*; with pencil on verso at lower left, *X 109*

WATERMARK: Strasbourg lily (cf. Churchill 400–428)

CONDITION: Discoloration; diagonal crease across sheet

PROVENANCE: R. Peltzer, Cologne (purple collector's mark [L.2231] on verso at lower right), sale, Stuttgart, May 13–14, 1914, no. 90, ill. (as Brouwer); C. B. Duhrkoop

REFERENCES: Paris 1929–33 under no. 1319 (as Koninck); Gerson 1936, no. Z. 270 (as Koninck); Lesley 1939, pp. 4, 5, ill. (as Brouwer)

Founders Society Purchase, William H. Murphy Fund (1938.17)

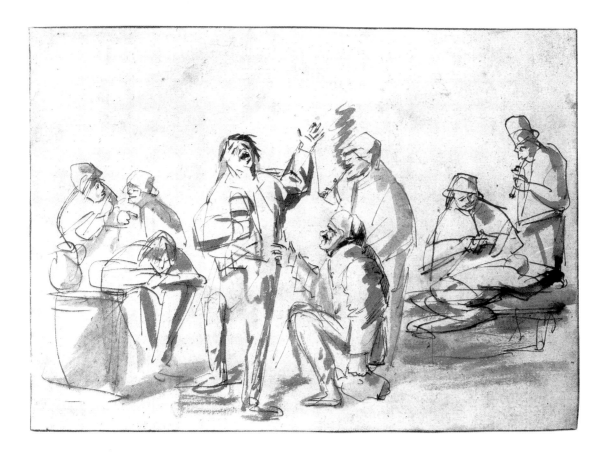

Many of these drawings representing tavern scenes were formerly attributed to Adriaen Brouwer, including this drawing in Detroit that bears an old attribution to the artist on the verso. Brouwer's drawings, however, are more spirited (see Knuttel 1962, pp. 167-174, figs. 113-118). Lugt deserves credit for identifying this study for the first time as a drawing by Philips Koninck, an opinion supported by Gerson.

Although known primarily as a painter of landscapes, as a draftsman Philips Koninck preferred figure studies and representations of biblical scenes. Lugt (Paris 1929–33) cites a number of similar renderings of peasants in taverns. None of these drawings relates to a known painting by Koninck. The earliest date found on one of the tavern scenes is 1660 (*Three Happy Peasants*, Kunsthalle, Hamburg, inv. 22 086; Gerson 1936, no. Z. 258). The Detroit sheet appears to be slightly later, ca. 1662, because the extensive use of brush and wash is similar to Koninck's study of *Three Nuns*, dated 1662 (Teyler Foundation, Haarlem; Gerson 1936, no. Z. 218).

For another drawing in Detroit that reflects Brouwer's subject matter, see Isaac van Ostade's *Study of Seven Peasants* (cat. no. 16).

Jan Luyken

1649 Amsterdam 1712

11.

Ptolemy Supervising the Construction of a Building in Alexandria (?)

Plate III

Pen and brown ink and brown, blue, purple, and gray wash over a preliminary drawing in black chalk on buff laid paper; 100 x 153 mm

CONDITION: Lined with thin paper; abrasions and repairs along edges; apparent loss of some color; slight cockling

PROVENANCE: E. Speelman, London

REFERENCES: *BDIA* 1935: 57 (as *Noah Building the Ark*); Scheyer 1936, no. 89

Founders Society Purchase, William H. Murphy Fund (1934.98)

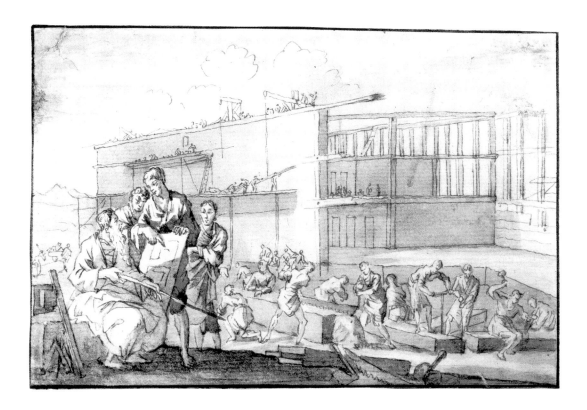

Besides being a painter and a poet, Jan Luyken was one of the most prolific draftsmen in the latter part of the seventeenth century. With his son Casper Luyken (1672–1708), who became his close collaborator, he left over four thousand drawings and prints, as Van Eeghen and Van der Kellen established (1905).

During his reign, Ptolemy II (308–246 B.C.) had a museum and a library, as well as a number of other buildings, erected in Alexandria. Luyken may have represented him here supervising the construction of one of these edifices. The drawing probably served as an illustration for a book which remains to be identified.

Dirk Maas

1659 Haarlem 1717

12.

*Landscape with Man on Horseback and
Woman Guiding a Donkey*

Plate IV

Black chalk and brush and gray ink and gray and
ocher wash on buff laid paper; 290 x 225 mm

ANNOTATIONS: With pencil on verso at center, *128 /
C. de R.*; with pencil on verso at center, *6* [in circle];
with pencil on verso at lower left, *J: Maas Pinxit /
J. Vrymoer fecit*; with pen and brown ink on verso in
lower left corner, *N 222*

WATERMARK: Strasbourg bend and lily (cf. Churchill
429–437)

CONDITION: Discoloration; foxing; stain upper
center

PROVENANCE: E. Parsons & Sons, London

REFERENCES: *BDIA* 1935: 57; Scheyer 1936, no. 84

Founders Society Purchase, William H. Murphy
Fund (1934.99)

The traditional attribution of the drawing is kept
here despite the fact that the execution is somewhat
more careful and detailed than is usual for Dirk
Maas; see, for example, his numerous drawings in
Munich (Munich 1973, nos. 708–741, pls. 289–300).
Julius S. Held suggested (verbally) the German
Johann Christoph Dietzsch (1710–1769) as another
possibility.

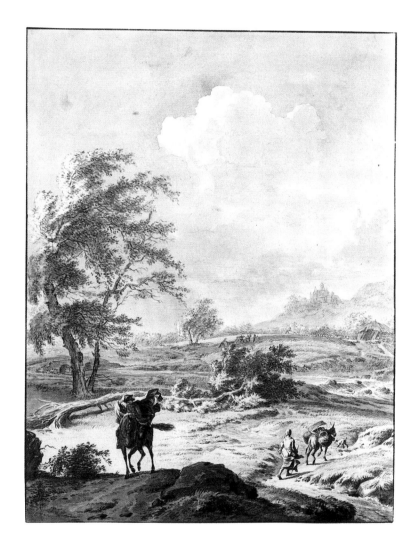

Willem van Mieris

1662 Leiden 1747

13.
Susannah and the Elders, 1690s (?)

Black chalk on parchment; 272 x 193 mm

ANNOTATIONS: With pencil on verso at lower left, *W.
v. Miris. [sic] F / te Utregt Peter G.*; with pencil on
verso at lower center, *708*

CONDITION: Minor cockling

PROVENANCE: Wunderlich & Co., New York;
James E. Scripps, Detroit

Gift of Mrs. James E. Scripps (1909.1 S-Dr. 177)

Van Mieris was one of a small number of artists who
favored parchment over paper for drawing. The rep-
resentation of Susannah surprised by the Elders,
based upon the story in the apocryphal Book of Sus-
annah (Daniel 13), is highly finished in the manner of
drawings presented as gifts. Van Mieris treated the
same subject once more in a watercolor signed and
dated 1691, formerly in the collection of H. R. Bijl,
The Hague (Christie's, London, November 26, 1973,
no. 318), and now in a private collection in The
Hague. The present drawing may also date from the
1690s.

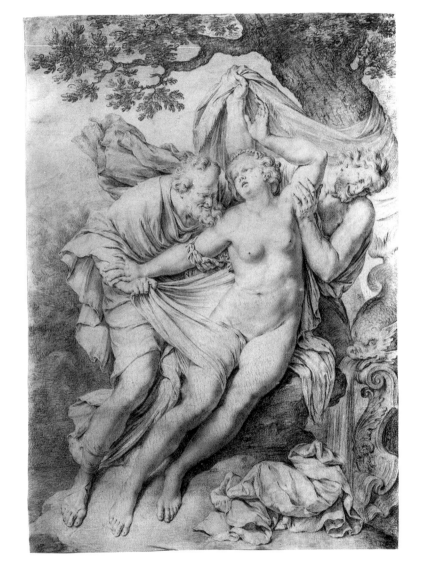

Pieter Molijn

1595 London – Haarlem 1661

14.
Landscape with Figures, 1654

Black chalk and gray brown wash on buff laid paper;
147 x 195 mm

INSCRIPTION: Signed and dated with black chalk on
recto at upper right, *PMolyn.* [*PM* in monogram] /
1654.

ANNOTATIONS: With pencil on verso at lower left,
VRN; with pen and brown ink on verso at lower left,
N. 2083.; with pen and brown ink on verso in lower
left corner, *2083* [crossed out]; with pencil on verso
at lower center, *183*; with pencil on verso at lower
right, *Pieter Molyn / geb. zu Harlem 1600. / mm.*;
with pen and brown ink on verso at lower right, *N⁰
37* [0] / *N⁰ 66* [crossed out]

CONDITION: Foxing; creasing along right edge may
have occurred during manufacture of sheet

PROVENANCE: Jhr. J. Goll van Franckenstein,
Amsterdam (brown collector's mark [L. 2987] on
verso at lower left, *N. 2083.*); Freiherr M. von Heyl
zu Herrnsheim, Darmstadt (purple collector's mark
[L. 2879] on verso at lower left); C. B. Duhrkoop

REFERENCE: *BDIA* 1939: 11, ill.

Founders Society Purchase, William H. Murphy
Fund (1938.18)

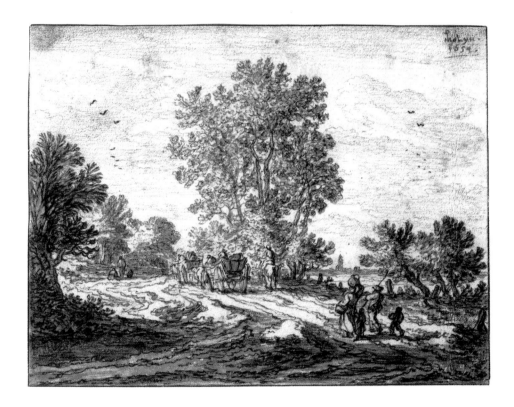

The drawing bears Molijn's signature at the upper
right and the date 1654. Another, almost identical
version of this sheet was recently acquired by the
Ackland Art Center in Chapel Hill, North Carolina
(black chalk and gray wash, 149 x 198 mm), which
was formerly in the collection of E. J. Otto, Berlin,
1956 (as pointed out by Hans-Ulrich Beck, letter to
the Detroit Institute of Arts, September 22, 1956;
Curatorial Files).

The Chapel Hill drawing bears Molijn's charac-
teristic signature at the upper right but lacks the
date. The one visible difference between these two
authentic versions is found in the tree in the center,
which in the Detroit drawing shows two additional
smaller shoots at the right. At least one other such
repetition is known in Molijn's oeuvre, also dating
from 1654: a drawing in the Victoria and Albert Mu-
seum (London 1874, no. 463) and its identical version
in a private collection in Hamburg (Hamburg 1965,
no. 124, fig. 149).

Monogrammist H. B.
(H. B. Blockhauwer?)

Active early seventeenth century

15.
Lansquenet with Shield and Pike, 1624

Pen and dark brown ink, heightened with white, on gray laid paper; 193 x 273 mm

INSCRIPTION: Dated with pen and brown ink on recto at lower right, *1624*

ANNOTATION: With pencil on verso at lower center, *84*

WATERMARK: R

CONDITION: Some crackle and flaking in heavier areas of ink; creasing left corner

PROVENANCE: D. Giese, London

REFERENCE: *BDIA* 1938: 40 (as Jacques de Gheyn)

Founders Society Purchase, William H. Murphy Fund (1937.18)

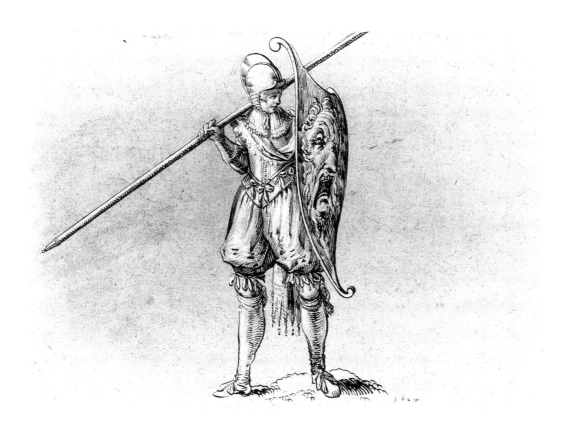

The drawing was formerly attributed to Jacques de Gheyn II until Egbert Haverkamp-Begemann (letter to Ellen Sharp, March 18, 1974; Curatorial Files) related it to the study of a standing figure in the Nationalmuseum, Stockholm, signed with the monogram *HB* and also dated 1624 (inv. NMH 2221/1863, as Hendrick Bloemaert). The Stockholm print room preserves two additional studies by the same hand representing a standing figure, both again dated 1624 (inv. NMH 2222/1863 and 2223/1863; from the collection of Count Carl Gustav Tessin in whose catalogue of 1790 they were listed as anony-

mous; information kindly conveyed by Börje Magnusson, letter to Ellen Sharp, May 12, 1975; Curatorial Files).

The Detroit drawing, together with the examples in Stockholm, are here tentatively attributed to H. B. Blockhauwer, a little-known amateur draftsman, whose drawing of *People Walking along a River* in the Pierpont Morgan Library, New York, is similar in execution. The latter sheet is signed and dated *hermen. Bertholomeus. Blockhauwer / ANNO 1621* (see New York 1979–80, nos. 48, 49, ill.).

Isaac van Ostade
reworked by an unknown artist

1621 Haarlem 1649

16.
Study of Seven Peasants, 1640s

Pen and brown ink and gray wash over graphite on buff laid paper; 128 x 187 mm

ANNOTATION: With pen and black ink on recto at lower right, *A* [indecipherable, cut off]

WATERMARK: F.D.

CONDITION: Replacements along top edge and in lower left corner; extensive foxing

PROVENANCE: E. Wauters, Paris (black collector's mark [L. 911] on recto at lower right), sale, Frederik

Muller & Cie, Amsterdam, June 15–16, 1926, no. 130 (as Adriaen van Ostade); sale, R. W. P. de Vries, Amsterdam, January 1929, no. 181, ill. (as Adriaen van Ostade); P. de Boer, Amsterdam

REFERENCES: Lees 1913, p. 133, fig. 151; *BDIA* 1938: 40 (as Adriaen van Ostade); Schnackenburg 1981, no. 586/U, pl. 249 (as a fragment of a sheet by Isack [*sic*] van Ostade, worked over by an anonymous hand with pen and brush); Logan 1984, p. 82

Gift of P. de Boer (1937.24)

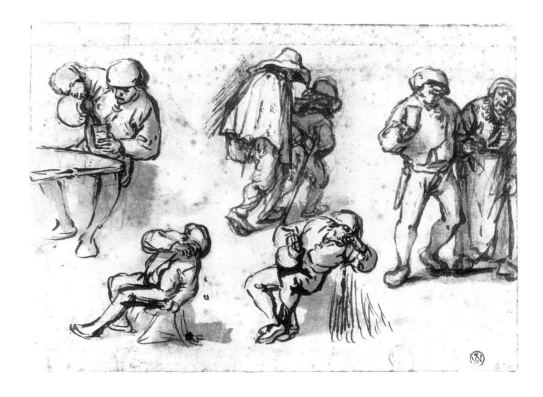

The drawing had traditionally been ascribed to Adriaen van Ostade (1610–1684) until Bernhard Schnackenburg attributed the part drawn in pencil alone to Adriaen's younger brother, Isaac van Ostade. As Schnackenburg explained in his monograph on the drawings by the two Van Ostades, at his sudden death in 1649, Isaac left a large number of sketchily drawn studies that had an "unfinished appearance." These drawings apparently remained untouched in the possession of his older brother until the latter passed away in 1685. At that time Adriaen's last student, Cornelis Dusart (1660–1704), inherited the contents of the studio of the two Van Ostade brothers. This accounts for the difficulty in attributing the drawings to either Adriaen or Isaac, since their work was always kept together. Dusart, moreover, cut drawings apart in order to form thematic groups and proceeded to "complete" a good number of them, in particular the sketchily drawn studies left by Isaac, adding brown wash and at times also pen and ink. (See also cat. nos. A7 and A8.)

The drawing in Detroit (according to Schnackenburg) is a fragment of a larger sketchbook sheet with a drawing in pencil only by Isaac van Ostade, which was reworked later with the pen and wash by an unknown hand. (In his opinion the penwork is not fine enough to be attributed either to Isaac himself or to Dusart.)

The two figures walking at top center relate closely to the two men disappearing into the distance at the right in Adriaen van Ostade's 1648 painting of *The Quack* in the Rijksmuseum, Amsterdam (Hofstede de Groot 1907–28: 3, no. 402; Amsterdam 1976, p. 429, no. A300).

The author would like to thank Dr. Bernhard Schnackenburg for information about the Detroit drawings given in a letter of August 2, 1977.

Roelant Roghman

ca. 1620 Amsterdam 1686

17.
*Landscape with Fortress and a Man on
Horseback*, after 1640

Pen and brown ink and brown and gray wash over a
preliminary drawing in black chalk on discolored
laid paper; 154 x 235 mm

INSCRIPTION: Signed with pen and brown ink on
recto at lower right, *Roelant. Roghman*

ANNOTATIONS: With pencil on verso at lower left,
o/; with pen and brown ink on verso in lower left
corner, □; with pencil on verso at lower right, *B* [in
circle]

WATERMARK: Fool's cap

CONDITION: Some discoloration; small loss lower
left edge; repaired loss near upper left corner; ver-
tical crease and some cockling left side

PROVENANCE: Unidentified collector (collector's
mark on verso); L. Deglatigny, Rouen (red collector's
mark [L. Suppl. 1768a] on recto at lower left), sale,
Paris, Hotel Drouot, June 14–15, 1937, no. 232; P. de
Boer, Amsterdam

REFERENCE: *BDIA* 1939: 11

Founders Society Purchase, William C. Yawkey Fund
(1938.73)

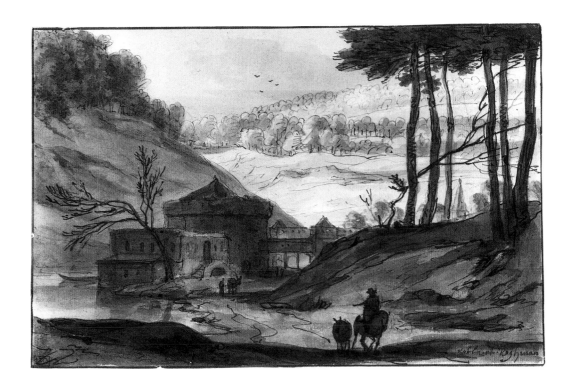

The hilly landscape, as well as the fortress in the
middle distance, recall the trip Roghman took to
Italy about 1640. The drawing, therefore, dates from
after this time. Related compositions, drawn freely
with the pen and washed in brown, are in the Lugt
collection, Paris (inv. 537; Paris 1968–69, no. 120, pl.
104), and in Berlin (Bock and Rosenberg 1930, p. 247,
nos. 3806 and 3810, pl. 178).

Circle of
Jacob van Ruisdael

18.
Farm Building by a Road

Black chalk and gray wash on discolored laid paper; 182 x 245 mm

ANNOTATIONS: With pencil on verso at lower left, [indecipherable] / [indecipherable] / *Jacob Ruysdael*; with pen and brown ink on verso at lower left edge, *Jacob Ruysdael fec / W. vK*

CONDITION: Extensive foxing; minor cockling; fold lines; some creasing; accretions in lower center and corners

PROVENANCE: Offered for sale, Boerner, Leipzig, 1909, no. 259, ill.; sale, Boerner, Leipzig, November 28, 1912, no. 211, ill. (as Jacob van Ruisdael); William Booth, Detroit; Fine Arts Associates, New York

REFERENCES: K. E. Simon in Thieme and Becker 1907–50, 29: 192 (as Cornelis Decker); *BDIA* 1945: 54, ill. (as Jacob van Ruisdael); Stampfle 1959, pp. 160–163 (as Jacob van Ruisdael); Giltay 1980, p. 178, n. 87 (as not Ruisdael)

Gift of Fine Arts Associates (1944.282)

The drawing has traditionally been attributed to Jacob van Ruisdael (1628/29–1682), although Jakob Rosenberg did not include it in his 1928 catalogue of Ruisdael's works. (A companion sheet, sold at the same Boerner sale in 1912 as lot 210, is now in Berlin [Rosenberg 1928, no. 7; according to Giltay 1980, p. 165, not Ruisdael].) While the composition is reminiscent of certain of Ruisdael's etchings (see, for example *Landscape with a Hut and a Shed*, signed and dated 1646; Hollstein 1949–, 20: 181, no. 11), the execution does not compare well with his drawing of a *View in Alkmaar* in the British Museum (London 1915–32, p. 40, no. 5, pl. XXIII; Rosenberg 1928, no. 47, pl. 154; Giltay 1980, no. 76). The even, horizontal lines drawn through the sky speak most strongly against Ruisdael's authorship.

K. E. Simon, whose catalogue of Ruisdael drawings in Thieme and Becker (1907–50, 29: 188–192) included a mere thirty-six originals, attributed the Detroit study, together with a sheet in the Louvre (Paris 1929–33, 2: no. 673, pl. XXXI) and another one sold in Berlin (sale, Graf R. de V. et al., May 4, 1931, lot 1254) to Cornelis Gerritsz. Decker (ca. 1620–1678), a landscape artist from Haarlem, who was a pupil of Salomon van Ruysdael (d. 1670; see K. Zoege von Manteuffel in Thieme and Becker 1907–50, 8: 521). Cornelis Decker is so little known, however, either as painter or draftsman, that the attribution is highly speculative. Wolfgang Stechow does not even mention him in his 1975 catalogue of Salomon van Ruysdael's paintings; in his 1966 study of Dutch seventeeth-century landscape painting, he refers to him briefly as an imitator of Salomon van Ruysdael (Stechow 1966, pp. 32, 60, 200, n. 45). The two signed paintings by Decker in the Staatliches Museum, Schwerin, and formerly with Habich in Kassel (Grosse 1925, p. 30, pls. 67, 68) are indeed similar in motif to the Detroit drawing, but insufficient proof for a firm attribution of the latter to the artist. (The painting in Schwerin is listed neither in Schwerin 1882 nor in Schwerin 1982.) One of the few other drawings attributed to Decker is preserved in the Berlin Kupferstichkabinett, representing a *House with a Waterwheel*.

Seymour Slive rejected the attribution of the Detroit drawing to Ruisdael, objecting to the mechanical hatching in the sky as well as to the stringy hatching of the thatched roofs. While, in his opinion, the treatment of the foliage bears some resemblance to passages in a few of Meindert Hobbema's (1638–1709) drawings, the rendering of the sky does not support an attribution to the artist (letter to the author, June 4, 1979).

Jeroen Giltay, to whom we owe a new evaluation of Jacob van Ruisdael as a draftsman, lists the Detroit drawing under the subheading no. 21, problem group 2 (p. 178), which includes three additional sheets that he attributes to the same hand: two in Amsterdam and one sold in Berlin in 1931, mentioned above as attributed to Decker. In his opinion there is a certain relationship with a drawing by Dirck Dalens (ca. 1600–1676) in the collection of R. Hardonk, Apeldoorn, but this relationship is not close enough for a firm reattribution of this small group.

Given these various opinions, it seems preferable to list the drawing among the anonymous Ruisdael followers.

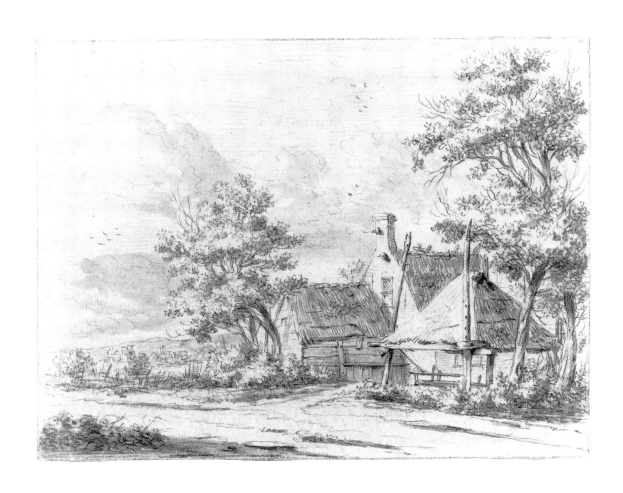

Attributed to
Pieter van Santvoort
ca. 1603 Amsterdam 1635

19.
Mountain Landscape with Ruins,
ca. 1630 (?)

Black chalk and brush and gray and black ink and gray wash on discolored laid paper; 224 x 341 mm

WATERMARK: Cockatrice

CONDITION: Decorative paper border attached to all four sides; skinned along top edge; foxing

PROVENANCE: Unidentified collector (collector's mark with pen and brown ink on verso at center left, *B*); Shaeffer Galleries, Inc., New York; John S. Newberry, New York, 1948

Gift of John S. Newberry (1959.65)

The drawing was once ascribed to an unknown late seventeenth-century Italian artist until Cornelius Müller Hofstede (letter to Ellen Sharp, June 12, 1970; Curatorial Files) suggested an attribution to Pieter van Santvoort, an attribution supported by J. Q. van Regteren Altena (verbally) and by Frits Lugt and An Zwollo (referred to in Müller Hofstede's letter). According to Lugt, it is one of Santvoort's best drawings; Zwollo considers it to be a late work of the artist.

The same castle on an identical mountain top appears in a slightly larger chalk drawing by Santvoort, formerly in the collection of Hofstede de Groot (258 x 404 mm; sale, Boerner, Leipzig, November 4, 1931, no. 319), which includes a bridge in the foreground left and a large house at the right. The Detroit drawing is a smaller, freer version of this drawing, which is more elaborate and slightly more detailed.

Although Müller Hofstede, Van Regteren Altena, Lugt, and Zwollo all seem to agree on an attribution to Pieter van Santvoort, the drawing has also been attributed to Roelant Roghman (see cat. no. 17), whose work dates primarily from the years after

Santvoort's death in 1635 (information in the Roghman files of the RKD). The attribution to Santvoort is based on a group of fourteen drawings in the Kunsthalle, Bremen, twelve of which were lost during World War II. Several of them bore the date 1623. The two surviving sheets are now in the Lugt collection, Paris (Paris 1968–69, no. 134, pl. 40).

Few securely attributed drawings by Santvoort are known. One of them, the signed landscape study in pen in Vienna, dated 1626, is very different in execution (inv. no. 8505; Bernt 1957–58, 2: no. 528, ill.). Many of the other drawings attributed to Santvoort formerly were given either to Paul Bril (1554–1626; for example, those in the Louvre; see Paris 1929–33, 2: nos. 706-708, pl. xxxviii) or to Roghman. Closest to the study in Detroit is a sheet in the Kunstmuseum, Düsseldorf, again with an old attribution to Roghman, a *Landscape with a Castle on a Hill in the Middle Distance* (Düsseldorf 1968, no. 97, pl. 17).

Since no late, signed drawings by Santvoort are known and since his draftsmanship at times is so close to Roghman, the drawing is here listed as attributed to Santvoort.

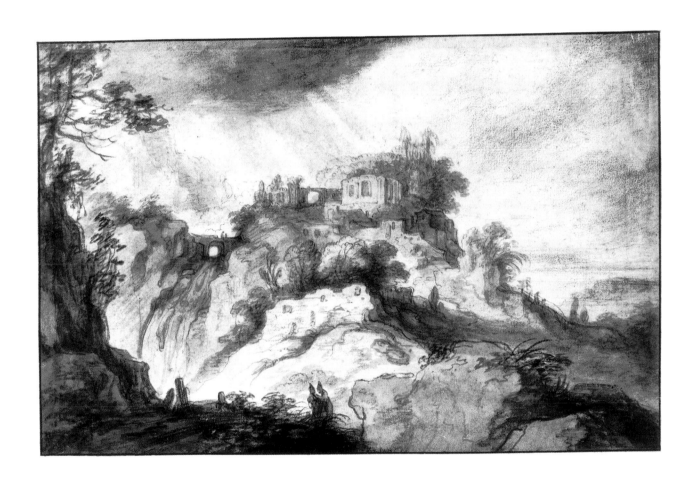

Herman van Swanevelt

ca. 1600 Woerden – Paris 1655

20.
Tobias and the Angel Encountering the Fish

Plate V

Pen and brown ink and gray wash over a preliminary drawing in graphite on discolored laid paper;
229 x 198 mm

INSCRIPTION: Signed with pen and brown ink on recto in lower right corner, *H. V. S.*

ANNOTATIONS: With pencil on verso at lower center, *Tobit and the Angel.- Esdaile writes that this beautiful drawing by Swaneveldt / was in the collection of Martin de Vos the Painter—whose / portrait was etched by Van Dyck. / signed by van Swaneveldt.*; with pencil on verso at lower left, *73270*; with pencil on verso at lower right, *Eoˣᵗ*; with pen and brown ink

on verso at lower edge, *WEsdaile. / 1834 WE 12xx M de Vos's Collⁿ H Swaneveldt* [by Esdaile]

WATERMARK: Details indecipherable, perhaps Heawood category "Grapes"

CONDITION: Abrasion; losses at edges

PROVENANCE: Jacob de Vos, Amsterdam, sale, October 30, 1833, Omslag U, no. 4 (as Herman Swanevelt); Samuel Woodburn, London; W. Esdaile, London (collector's mark [L. 816] with pen and brown ink on verso at bottom); sale, Christie's, London, June 18, 1840, under no. 929; Frederick Keppel, New York; James E. Scripps, Detroit, 1887

Gift of Mrs. James E. Scripps (1909.1 S-Dr. 285)

In the apocryphal Book of Tobit (6:2), Tobias, accompanied by the angel Raphael (whose true nature is unknown to the youth), is on his way to Media to collect money owed to his blind father, Tobit. Arriving at the river Tigris, the youth tries to bathe but is chased away by a fish. The drawing depicts the frightened Tobias running toward the angel, who instructs him to catch the fish but to save its heart, gall, and liver—the heart and liver drive out evil spirits, while the gall heals blindness, thus guaranteeing a happy ending for both Tobias and his father.

The story of Tobit is found in one of the apocryphal books of the Old Testament that became part of the Dutch Bible in 1618, during the Synod of Dordrecht. Its fourteen short chapters deal above all with the necessity of man's complete faith in God. The Tobit theme was already popular with Dutch artists of the sixteenth century, such as Barent van Orley (1490/92–1541/42), Jan Swart (ca. 1500–after 1553), and Maerten van Heemskerck (1498–1574), but found its most personal and human interpretation in the work of Rembrandt, who rendered various aspects of it in some fifty-five known paintings, drawings, and etchings, dating most often from the 1640s and 1650s (Held 1964).

The execution of the drawing may be compared to signed studies by Herman van Swanevelt such as the *Landscape with Bathers* at Windsor Castle, dated 1632 (inv. 6290; Bernt 1957–58, 2: no. 558, ill.). In the Windsor drawing we find a somewhat freer, more varied pen stroke. The same holds true for another rendering by Swanevelt of *Tobias and the Angel Carrying the Dead Fish*, where the contours of the figures as well as the trees and leaves are drawn less rigidly (Ecole des Beaux-Arts, Paris, inv. 34 637; Paris 1950, no. 640, pl. LXXIX). A related drawing, identical

in size, also attributed to Swanevelt and representing the *Angel Appearing to Elijah*, is in the collection of Paul Brandt in Amsterdam (Utrecht 1963, no. 82, ill.; Dordrecht 1968, no. 107, ill.; also from the De Vos and Esdaile collections).

The composition relates (in reverse) to Swanevelt's etching *Landscape with Tobias Frightened by the Fish*, executed in Rome, ca. 1630s (Leach and Morse 1978, p. 272, no. 68, ill.).

The monogram in the Detroit drawing differs from Swanevelt's usual form in that the letters H. V. S. are placed next to each other, whereas Swanevelt generally joined them, ligating the *H* with the *V*, while superimposing the *S* over the right arm of the *V*. The possibility thus exists that the drawing is based on a lost prototype by the artist.

In his annotation, William Esdaile (1758–1837) must have been referring to the collector Jacob de Vos (1735–1831), whose large holdings of old master drawings were sold through C. S. Roos on October 30, 1833, in Amsterdam, rather than to the Flemish painter Marten de Vos (1532–1603; see cat. nos. 58 and A15), as his pencil annotation on the verso of the Detroit drawing has it (the author appreciates the reference to the collector Jacob de Vos provided by Mark C. Leach). Lot 4 of "Omslag U" contained two drawings by Herman van Swanevelt of "Wooded views on a riverbank, both with historical figures. Very nice and executed with pen and brown ink" [*Twee stuks Boschgezigten aan den oever eener rivier, beide historieel gestoffeerd. Zeer fraai, en uitvoerig met pen en o.i. inkt*]. They most likely are identical with the drawing in Detroit and the one in the collection of Paul Brandt in Amsterdam. The lot was bought by Samuel Woodburn who in turn sold it to Esdaile.

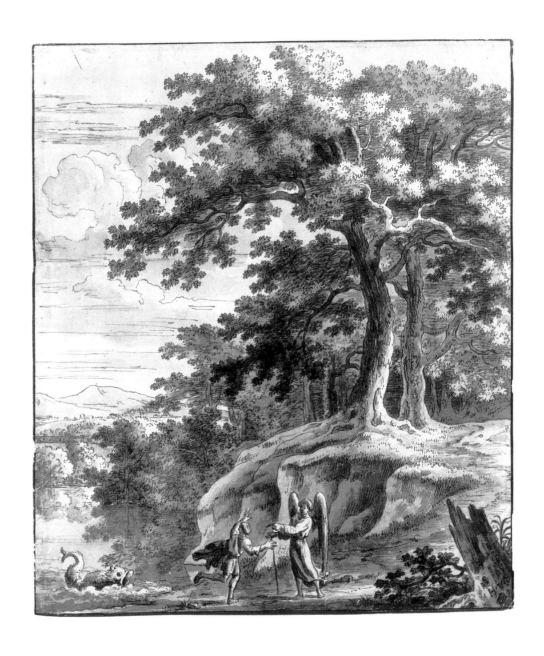

Gerard Terborch the Younger

1617 Zwolle – Deventer 1681

21.
Head of a Boy, ca. 1633–35

Plate VI

Pen and brown ink and gray wash on buff laid paper;
64 x 58 mm

INSCRIPTION: Signed with brush and gray ink on
recto at upper right, *TBurg* [in monogram]

CONDITION: Small edge tears; some discoloration;
foxing

PROVENANCE: J. Q. van Regteren Altena, Amsterdam; E. Speelman, London

Founders Society Purchase, William H. Murphy
Fund (1934.160)

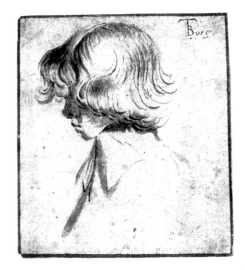

This small portrait study was drawn by Terborch
when he was twelve or thirteen years old, according
to S. J. Gudlaugsson (verbally, March 13, 1956). A
slightly later date of 1633–35 would seem preferable,
however, because in execution the drawing closely
relates to another small study of a youth in the
Museum Boymans-van Beuningen, Rotterdam (inv.
H. 257), which supposedly originated during Terborch's apprenticeship with Pieter Molijn (see cat.
no. 14) in Haarlem during those years. Even the inscription at bottom right is close to the one found on
the Detroit drawing.

Both of these studies may be associated with a
group of pen and wash drawings in Amsterdam and
Berlin by Gerard's father, Gerard Terborch the Elder
(1584–1662), probably rendering Gerard's younger
sisters, Anna, Sara, or Gesina. These small portrait
studies by both father and son are extremely close,
the son most likely being inspired by his father's
work.

Terborch the Elder not only closely supervised
his son's education and collected his early attempts
at drawing, but he also inscribed them and provided
them with dates. As a result, his son's oeuvre is the
most complete and best documented of any seventeeth-century Dutch artist. Much of this collection,
the so-called "Ter Borch Family Album," is now in
the Rijksmuseum, Prentenkabinet, Amsterdam (see
Münster 1974, pp. 203 ff.).

Unknown Dutch Artist

Active seventeenth century

22.
A Young Man Playing Cards

Red chalk over traces of black chalk on buff laid paper; 285 x 195 mm

ANNOTATION: With pencil on verso at lower left, *Gerard ter borch*

CONDITION: Foxing; surface grime; minor stains; lower left and right corners abraded; scattered creasing. A number of deposits of red, black, and blue materials on both the recto and verso bear no relation to the image and are most likely transfers from other drawings. The white retouches may have been made to cover the most obtrusive marks.

PROVENANCE: Sale (Collection L.X. Lannoy, et al.), R. W. P. de Vries, Amsterdam, May 19–28, 1925, no. 78, ill. (as Gerard Terborch); N. Beets, Amsterdam

REFERENCES: *BDIA* 1935: 57; Scheyer 1936, no. 79 (as Gerard Terborch the Younger)

Founders Society Purchase, Laura H. Murphy Fund (1934.103)

This study of a cardplayer, once attributed to Gerard Terborch the Younger, cannot be associated with any known painting by that artist. The use of red chalk as well as its rather dense, even application is unknown in Terborch's oeuvre, as may be seen from a comparison with genre studies attributed to him in the Albertina, probably dating from the later 1660s (for example, the *Man Seated, Jug in Hand*, Eisler 1976, pl. 85; and the *Woman Seated, Shuffling Cards*; Münster 1974, no. 108. Both drawings appear to be annotated by Terborch's sister Gesina, and one of them is also dated 1669). The study in Detroit therefore is listed among the unknown Dutch drawings.

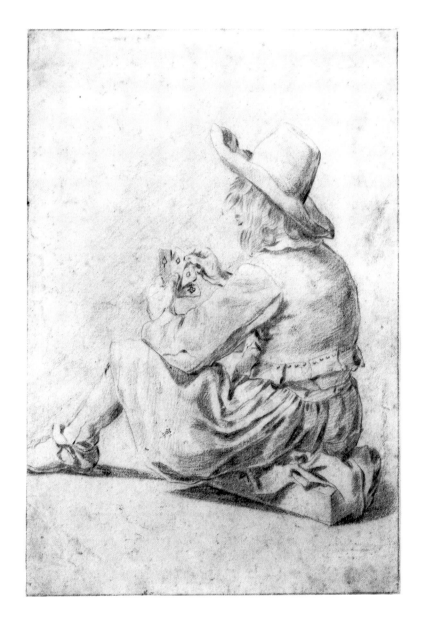

Color Plates I – XVI

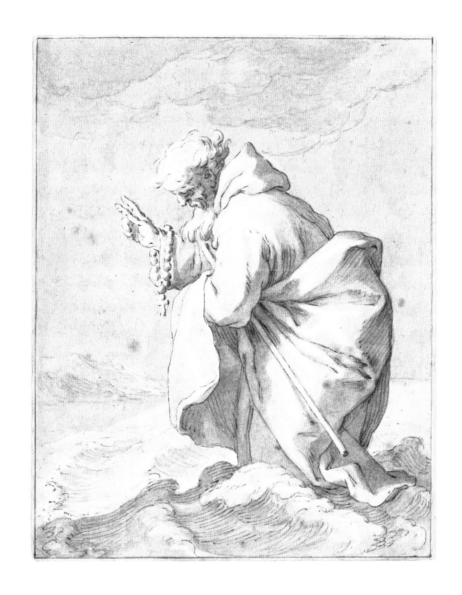

Plate I Abraham Bloemaert, *Saintly Hermit, Walking on Water* (cat. no. 2)

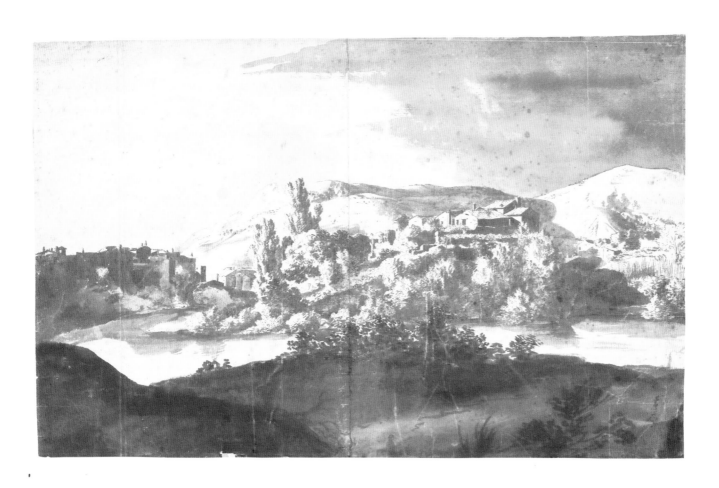

Plate II Bartholomeus Breenbergh, *Italian Village on a River* (cat. no. 5)

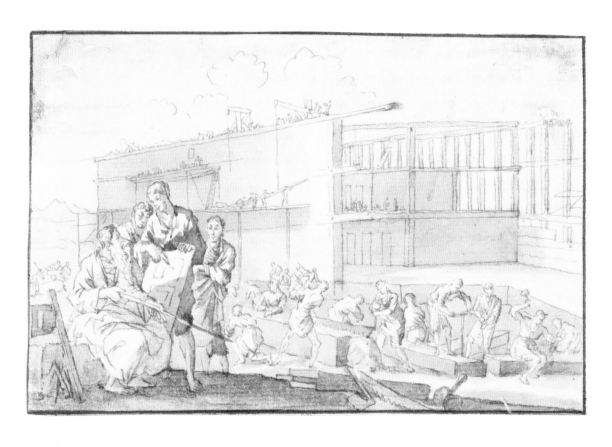

Plate III Jan Luyken, *Ptolemy Supervising the Construction of a Building in Alexandria* (?) (cat. no. 11)

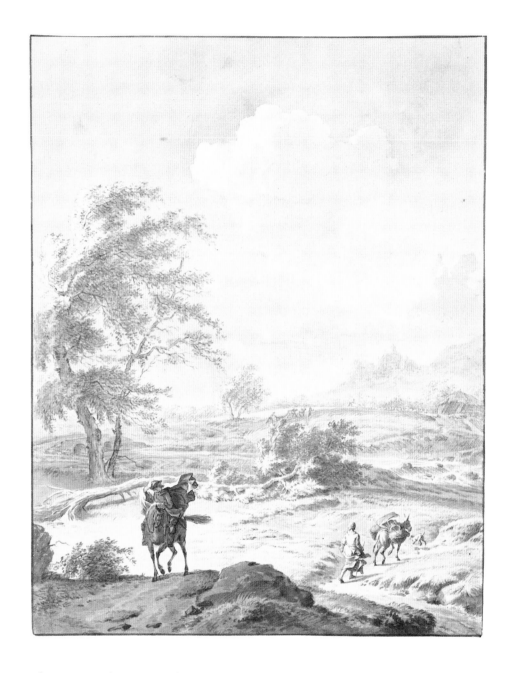

Plate IV Dirk Maas, *Landscape with Man on Horseback and Woman Guiding a Donkey* (cat. no. 12)

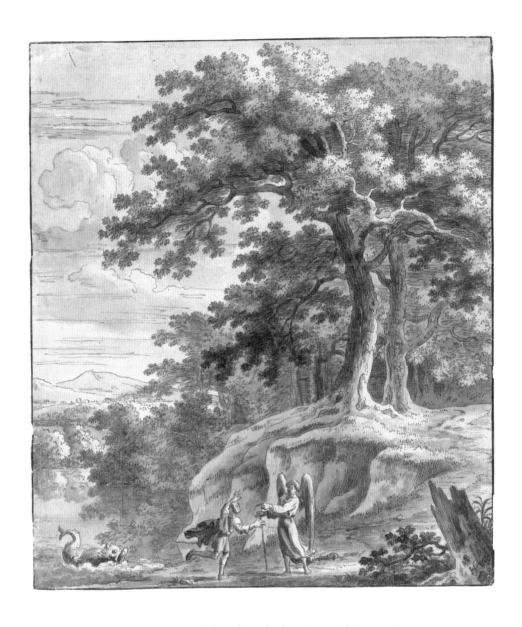

Plate V Herman van Swanevelt (attributed to), *Tobias and the Angel Encountering the Fish* (cat. no. 20)

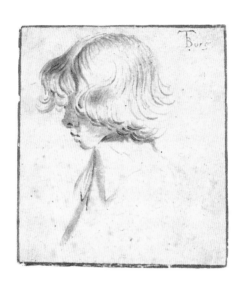

Plate VI Gerard Terborch the Younger,
Head of a Boy (cat. no. 21)

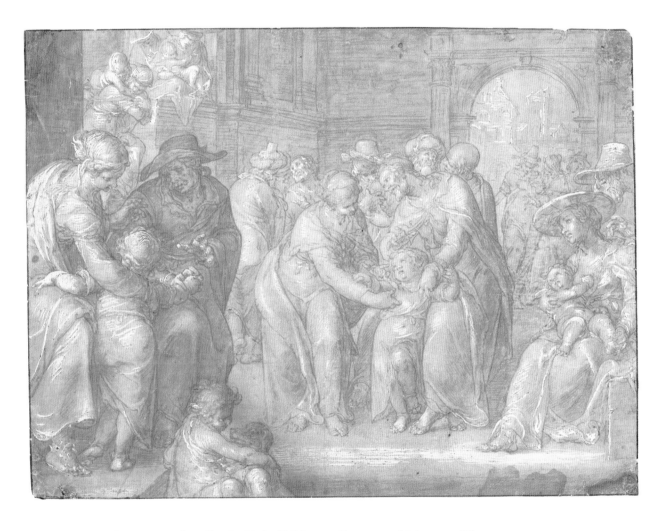

Plate VII Joachim Wtewael, *Suffer the Little Children to Come unto Me* (cat. no. 25)

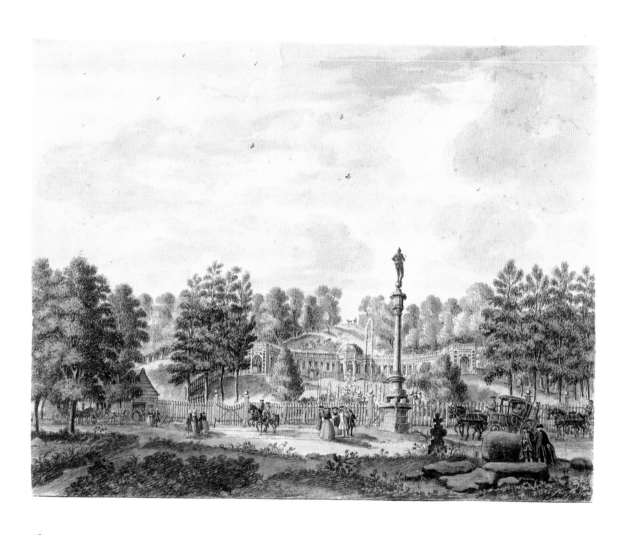

Plate VIII Jan de Beyer, *The Amphitheater at Cleves with the Statue of the "Iron Man"* (cat. no. 26)

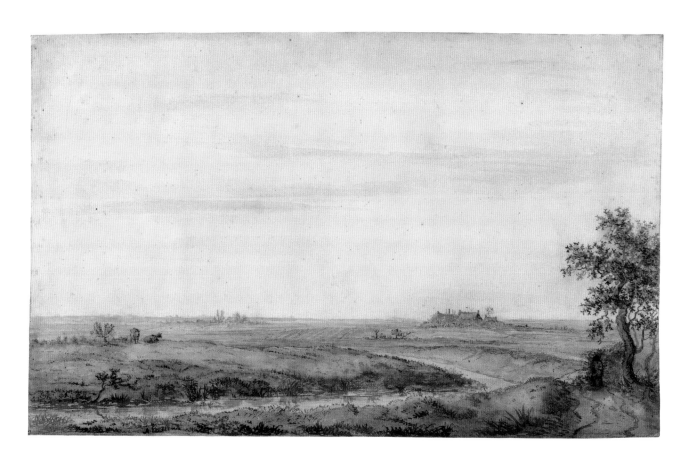

Plate IX A. (Anthonie?) Erkelens, *Landscape* (cat. no. 27)

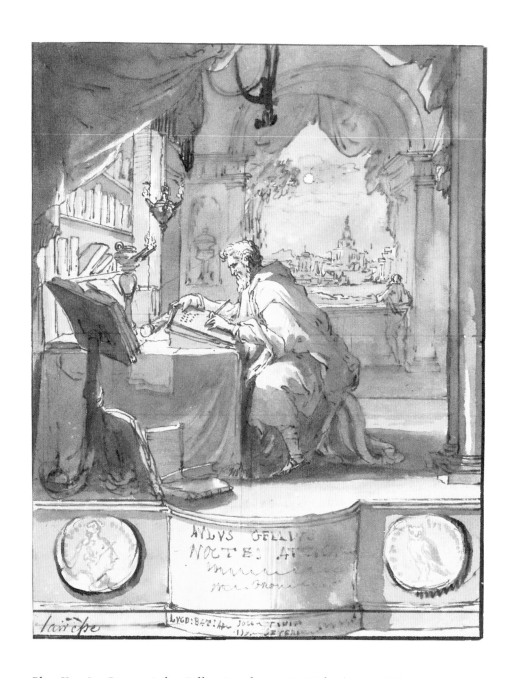

Plate X Jan Goeree, *Aulus Gellius Finishing* Attic Nights (cat. no. 28)

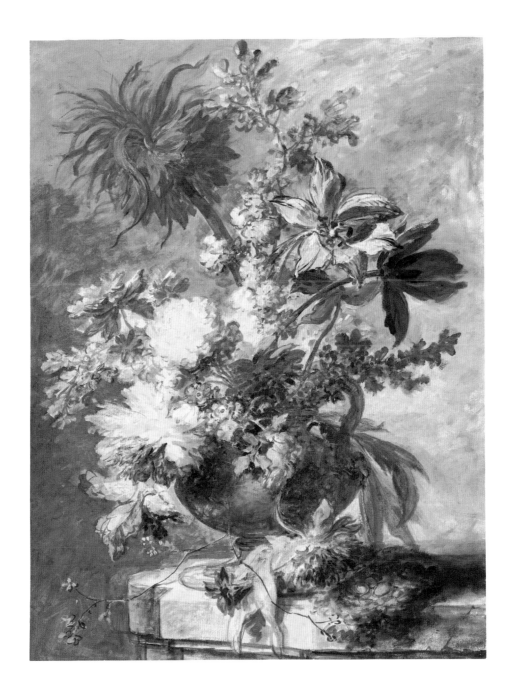

Plate XI Jan van Huysum, *Flowers in an Urn on a Plinth* (cat. no. 29)

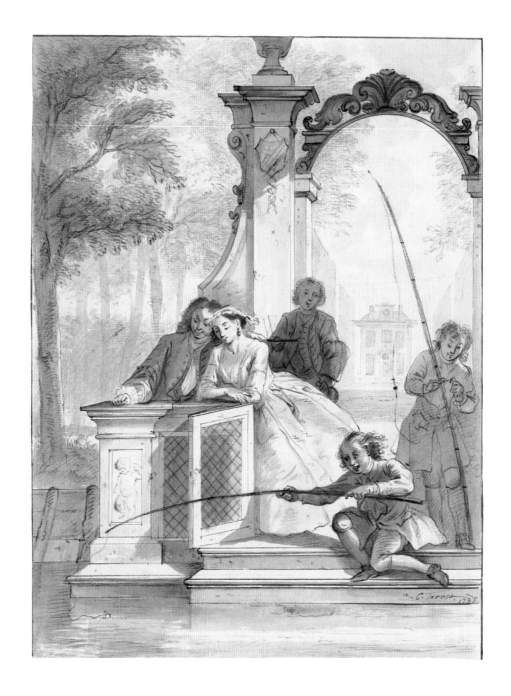

Plate XII Cornelis Troost, *The Fishing Party* (cat. no. 32)

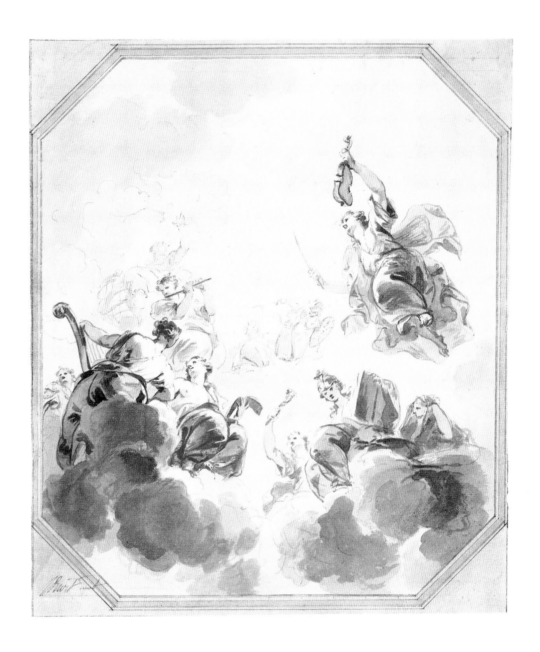

Plate XIII Jacob de Wit, *Apollo Enthroned with Minerva and the Muses* (cat. no. 33)

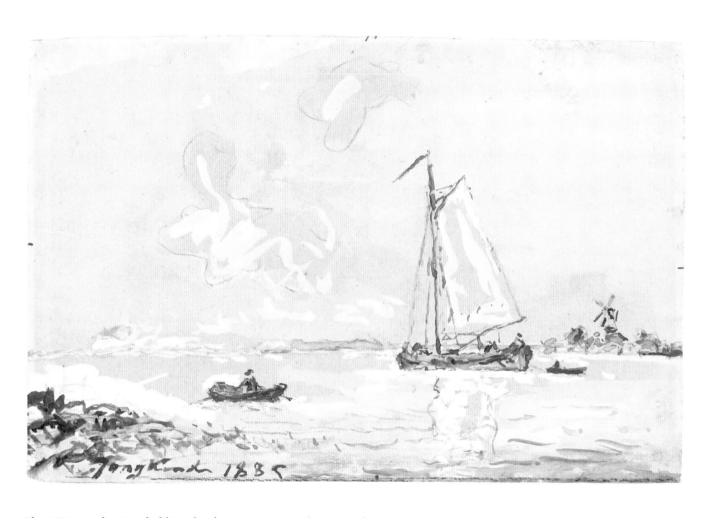

Plate XIV Johan Barthold Jongkind, *Boats on a River* (cat. no. 37)

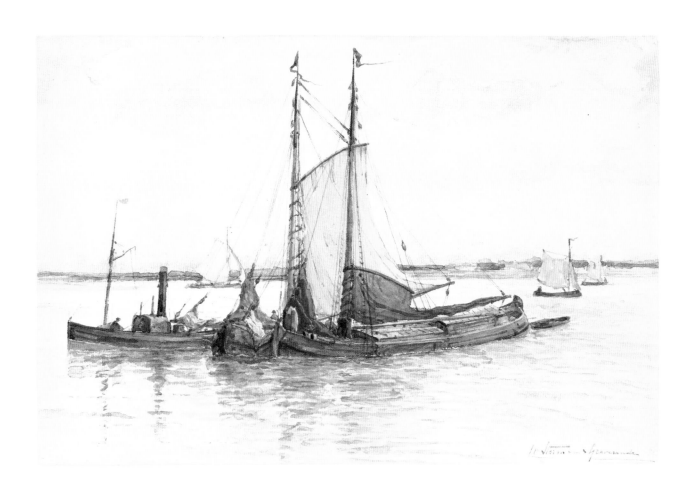

Plate XV Carel Nicolaas Storm van 's Gravesande, *The Maas off Dordrecht* (cat. no. 49)

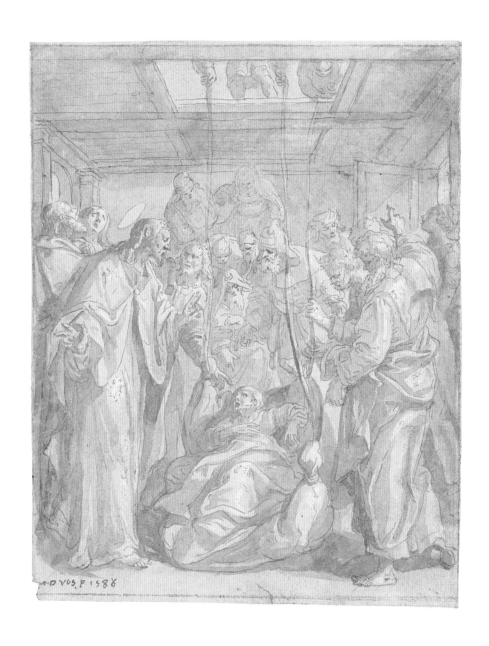

Plate XVI Marten de Vos, *Christ Healing the Palsied Man* (cat. no. 58)

Unknown Dutch Artist

Active seventeenth century

23.
Soldier Playing Cards

Black chalk accentuated with brown chalk on discolored laid paper; 162 x 140 mm

ANNOTATIONS: With pencil on verso at lower left, *Le D...* [indecipherable]; with pencil on verso in lower left corner, *fnus* [?]; with pencil on verso at lower center, *8*; with pencil on verso at lower center edge, *25* [?]

CONDITION: Discoloration left edge; foxing; surface grime

PROVENANCE: J. D. Böhm, Vienna (blue collector's marks [L. 271 and L. 1442] on verso in lower left corner); Mrs. Ernest C. Innes, sale, Christie's, London, December 13, 1935, no. 19 (as Pieter de Hooch); E. Speelman, London; Wilhelm R. Valentiner, Detroit

REFERENCES: *BDIA* 1939: 11 (as Pieter de Hooch); Sutton 1980, cat. D43, pl. 194 (not Pieter de Hooch)

Gift of Dr. Wilhelm R. Valentiner (1938.62)

The earlier attribution of the drawing to Pieter de Hooch (1629–1684) can no longer be supported, despite the fact that it probably was made by Wilhelm R. Valentiner. Valentiner not only published a volume in the *Klassiker der Kunst* series on the artist in 1929, but he also donated this study to the Detroit Institute of Arts while he was director.

The figural type represented in this cardplayer is uncommon in Pieter de Hooch's painted oeuvre and no securely documented or attributed drawing is known by the artist. Without comment, Peter Sutton lists the drawing in his recent monograph among the wrongly attributed works (one of five thus listed; nos. D39–43, pls. 190–194).

Frits Lugt, in an annotation on the photo of the Detroit drawing kept at the RKD, tentatively suggested the Dutch genre painter Ludolf de Jongh (1616–1679), whose interior scenes in a few instances come close to those of De Hooch. Another painter whose figures are reminiscent of the cardplayer in the Detroit drawing is Hendrik van der Burch (1649–after 1669), a Dutch painter of domestic interiors, very much in the style of De Hooch, who was active at Delft, Leiden, and Amsterdam. The drawing, therefore, most likely reflects a study by another artist working in the manner of De Hooch. Furthermore, the rather pale appearance of the drawing, as well as the predominant parallel hatching from left to right, suggest that the drawing may be a counterproof that subsequently was touched up and strengthened with brown chalk.

Esaias van de Velde

ca. 1590 Amsterdam – The Hague 1630

24.
*Tree Fallen over a Path and Figures
Conversing*, 1626

Graphite and black crayon on off-white laid paper
with a pen-and-brown ink border; 190 x 223 mm

INSCRIPTION: Signed and dated with black chalk on
recto at lower center, *E.V.VELDE.1626* [faded, barely
legible, and partially cut off]

ANNOTATIONS: With pencil on verso at lower left,
E v. d Velde; with pencil on verso at center left, *a*ᵘ;
with pencil on verso in lower left corner, *00010*

CONDITION: The principal lines of the drawing have
bled through to the verso, indicating that there may
be an oily or corrosive element in the media; foxed
over all

PROVENANCE: Sale, M. H. M. Montauban van
Swijndrecht..., R. W. P. de Vries, Amsterdam, April 5,
1906, lot 209; sale, M. O. Brenner of Berlin and oth-
ers, R. W. P. de Vries, Amsterdam, December 14, 1911,
lot 1500; sale, V. van Gogh and others, R. W. P. de
Vries, Amsterdam, December 2, 1913, lot 809; sale,
R. W. P. de Vries, Amsterdam, 1924, sales cat. no.
558; George Kamperman, Detroit

REFERENCES: *BDIA* 1947: 45; Keyes 1984, cat. no.
D 157, pl. 169A

Gift of Dr. and Mrs. George Kamperman (1946.175)

Most closely related to this drawing both in subject
matter as well as execution is Esaias's signed draw-
ing formerly in the Oscar Huldschinsky collection in
Berlin (Keyes 1984, cat. no. D182; current location
unknown), which bears the date 1626. This corre-
spondence between the drawings indicates that the
badly faded date inscribed on the Detroit drawing at
lower center more likely reads 1626 than 1625. Ac-
cording to George Keyes, who kindly provided infor-
mation for the earlier provenance of the drawing, the
sheet may once have been part of a group of related
drawings (letter to Marilyn Symmes, December 13,
1975; Curatorial Files). Similar landscape studies by
Esaias van de Velde that also originated in the late
1620s are the signed and dated drawing of 1627 in the
Lugt collection, Paris (Paris 1968–69, no. 156, pl. 41;
Keyes 1984, cat. no. D201) and the signed drawing in
the Louvre (Paris 1929–33, 2: no. 799, pl. LVIII; Keyes
1984, cat. no. D200).

Joachim Wtewael

1566 Utrecht 1638

25.

Suffer the Little Children to Come unto Me, ca. 1621

Plate VII

Red chalk over a preliminary drawing in black chalk, heightened with white, on discolored buff laid paper with a gray prepared ground; 276 x 371 mm

ANNOTATIONS: With pen and brown ink on verso at lower left, *A Blommaart* [*A* and *B* in monogram]; with pencil on verso at lower left, *Nº 1134.* [crossed out]; with pencil on verso at lower center, *3234*; with pencil on verso at lower right, *3234* [crossed out]; with pencil on verso at lower right, *Joachim Wijtenwael*; with pen and brown ink on verso at lower right [indecipherable]

WATERMARK: Eagle with crozier of Basel (cf. Labarre 256)

CONDITION: Worn, many repairs at edges; staining, retouched in scattered locations, most notably left of center; some white lead discoloration; abrasion of image right edge and just right of center; vertical fold line at center

PROVENANCE: Sir Thomas Lawrence, London; R. E. Lewis, San Francisco

EXHIBITION: Poughkeepsie 1970, no. 105

REFERENCES: Lindeman 1929, p. 64, pl. XVII, 1; *BDIA* 1959/60: 44; Poughkeepsie 1970, no. 105, pl. 60; Logan 1971, p. 277, fig. 2; Lowenthal 1986, under no. A 85, pl. 118

Founders Society Purchase, Hal H. Smith Fund (1959.4)

Christ, standing in the center, has instructed his disciples to let the children approach so that he can lay his hands upon them and bless them (Mark 10:13–16). Wolfgang Stechow identified this drawing as Wtewael's preliminary study for his signed painting of 1621 in Leningrad (Poughkeepsie 1970, no. 105. For the painting, see Lindeman 1929, p. 250, no. XIV, pl. XVII; Leningrad 1958, 2: 285, no. 709; Lowenthal 1986, under no. A85). The drawing deviates only in minor details from the finished painting, primarily in the altered positions of the heads of the principal figures in the foreground. A comparison with the painting indicates, furthermore, that the drawing must have been clipped at the left, right, and at the bottom. A copy after the Leningrad painting (*Christ Blessing the Children*, inv. 709) in 1973 was with G. J. Scherpel, Bussum (Lowenthal 1986, p. 166, no. C–14).

Jan de Beyer

1703 Aarau, Switzerland – Cleves 1768

26.
The Amphitheater at Cleves with the Statue of the "Iron Man," 1746

Plate VIII

Pen and black ink and watercolor on buff laid paper; 156 x 199 mm

INSCRIPTIONS: Signed with pen and brown ink on verso at lower left, *J:de Beijer ad viv: delin:*; with pen and brown ink on verso at lower center, *gezigt tot Cleef in den Diergaerde agter den ysere Man. / in de Fonteine van de Galderie.*— [additional inscription below cut off]

ANNOTATION: With pencil on verso at lower left, *1530*

CONDITION: Upper portion flecked with gray spots or discoloration; paper thinned upper left corner and left edge verso

PROVENENCE: Hanns Schaeffer, New York

REFERENCE: Verbeek 1957, no. 124

Gift of Hanns Schaeffer (1945.6)

Cleves, now in West Germany, was frequently visited by Dutch artists, especially during 1648–66, the years when the Elector of Brandenburg, Friedrich Wilhelm, and his Dutch wife, Princess Louise Henriette of Orange, resided in that city. In 1647, the elector appointed Johan Maurits, later Prince of Nassau-Siegen, as *stadholder* (proconsul), a post he retained until his death in 1679. Thanks to him, Cleves became a beautiful city, a worthy seat for the Elector of Brandenburg and his family.

The drawing shows the amphitheater, built in 1711–12, in a view from the southwest. It was situated on the so-called Springenberg in the "Tiergarten," a large park in which deer roamed, in the northwest part of Cleves. A similar view of the earlier amphitheater is found in the background at the right of Jan de Baen's (1633–1702) portrait of Johan Maurits of 1660, known in a number of versions, among them the ones in the Mauritshuis, in The Hague, and in the Städtisches Museum, Haus Koekkoek, in Cleves (see Cleves 1979, pl. 1). The Springenberg was part of a grand design that Johan Maurits had commissioned from Jacob van Campen (1595–1657), the architect of the Mauritshuis (1633), the residence of Johan Maurits, and of the Amsterdam Town Hall (begun in 1648).

Initial work for this garden project dates back to 1653, when a number of trophies were erected on the Springenberg at selected points, as may be seen in a drawing of 1654(?) (inv. no. 1970.5; ibid., pl. v) in Amsterdam, now attributed to Hendrik Feltman (1610–1670; previous attributions were to Anthonie van Borssom [1629/30–1677] and Gerbrand van den Eeckhout [1621–1674]). Among these early trophies

was the statue of the *Iron Man* (or *Iron Mars*), seen in the center foreground in De Beyer's drawing, which was erected on December 22, 1653, at the foot of the Springenberg. This *Iron Man* was placed in front of the fence that closed off the "Tiergarten" proper. The figure of Mars wearing a piece of armor stood upon a sphere, which in turn was placed on a stone column that rested on five cannon balls on top of a millstone. According to tradition the armor belonged to Marten Schenk and was presented to Johan Maurits in recognition of the latter's courage during the capture of the "Schenkenschanze" in 1636 from the Spaniards. Maria van Aeckerlaecken described the statue in her poem of 1653 as *Iseren Man* and alluded to the reuse of the armor in a peaceful context (see De Jong in Cleves 1979, pp. 195–204). The amphitheater proper was begun in 1656 and consisted of a center pavilion, from which extended a semicircular arcaded gallery. Lambert Doomer (1624–1700) depicted it from below in a drawing dated ca. 1663 in the British Museum (see Sumowski 1980–, no. 401, ill.), and the view by Jan van Call the Elder (1655–1705?) of ca. 1685 in Amsterdam is taken from about the same spot later chosen by Jan de Beyer (Cleves 1979, pl. VIII). The park was badly damaged during the War of the Spanish Succession in 1702. The wooden amphitheater Maurits built was replaced in 1711–12 under King Friedrich I of Prussia. It then consisted of fourteen arcades, rather than eleven, which flanked an octagonal pavilion on either side. This is the amphitheater known from four drawings by Jan de Beyer, among them the example in Detroit, which was engraved by Hendrik Spilman (1721–1784) in 1746 (fig. 3).

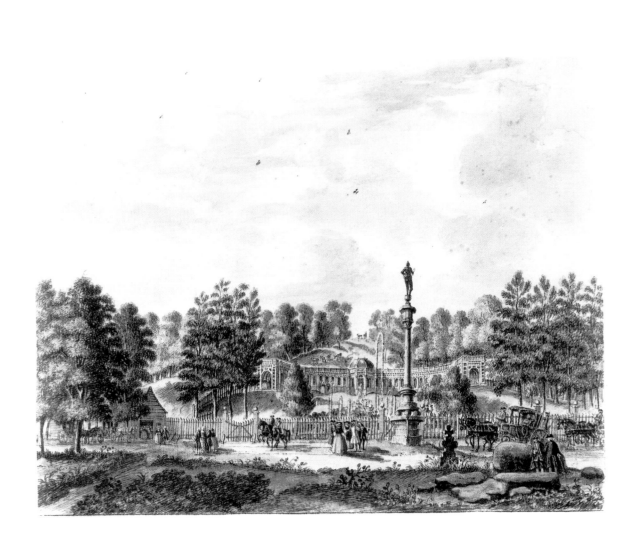

De Fonteinen, en het Amphitheater, te zien achter de Statue, genaamd de Yzere | La Fontaine et l'Amphithéatre, regardés du coté de la Statuë de Fer
Man.

Fig. 3.
Hendrik Spilman, Dutch, after Jan de Beyer. *The Amphitheater of Cleves with the Statue of the "Iron Man,"* 1746. Engraving, 238 x 401 mm. Städtisches Museum, Haus Koekkoek, Cleves. Photo: Städtisches Museum.

On the Springenberg, the architect Van Campen had collected the various springs in a series of water basins, arranged in an axis on the terraced grounds below with the amphitheater as the focal point. Visible in the center of De Beyer's drawing is the upper one of the four fountains, which included the statue of *Minerva* by Artus Quellinus (1609–1668), a gift to Johan Maurits from the city of Amsterdam and installed in 1660. Since Mars and Minerva are often seen together in seventeenth-century allegorical representations, it appears likely that she was placed there intentionally, for Minerva advised Mars against starting unnecessary wars. This served to protect the arts, which flourished in times of peace (see De Jong and Hilger in Cleves 1979, pp. 189–194). The next fountain contained the figure of the *Manneken Pis*, while the third one was the so-called Roman fountain, seen most clearly in Doomer's sketch mentioned above. A series of provincial Roman

stone monuments was positioned around it, hence its name. The *Fontana miranda*, finally, with artificially arranged rocky scenery and waterfalls, is reminiscent of fountains of Roman villas. These terraced fountains are best documented in a painting attributed to Anthonie van Borssom in the Kaiser-Wilhelm-Museum in Krefeld (see Cleves 1979, pl. VI, and Diedenhofen in Cleves 1979, pp. 165–188, on the gardens of Johan Maurits at Cleves).

The various views De Beyer drew of Cleves date from 1745–46, when the artist was commissioned for designs to illustrate two books on the city, published in 1747 and 1752, respectively: Pieter Langendijk, *De Stad Klef, haar gezondheidbron en omleggende landsdouwen, in kunstprenten verbeeld, berymd en met aantekeningen opgehelderd*, published by Jan Bosch in Haarlem, included prints after ten drawings by De Beyer, among them the sheet in Detroit; the second volume, *Kleefsche Waterlust ofte Beschrijving van*

de lieflijke Vermaekelijkheden aen de Wateren te Kleef, was published by Isaac Bruynih in Amsterdam with eleven prints after drawings by De Beyer. The text of the latter volume was written by Johann Heinrich Schütte, a medical doctor living in Cleves. In 1741–42 Schütte had discovered mineral springs at the foot of the Springenberg, which were covered by the wooden house at the lower left in De Beyer's drawing.

Jan de Beyer made the drawing on the site, as his inscription on the verso, *ad viv* [*um*] *delin* [*eavit*], indicates. The design engraved by Spilman in 1746 was used as plate IX in Langendijk's book (Verbeek 1957, fig. 120). Spilman introduced a few changes in his print, most notably in the foreground, where he included the artist himself drawing the view from a spot behind the *Iron Man*. De Beyer's drawing also served for the title vignette of Langendijk's publication. (The drawing was unknown to Romers in 1969 and is not listed in Cleves 1980, an exhibition that tried to assemble all the known drawings by De Beyer of Cleves. Many of the drawings are still in private collections, other large groups are preserved at the Rijksmuseum, Prentenkabinet, in Amsterdam and at the Bibliotheek van Provinciaal Genootschap in 's-Hertogenbosch.)

De Beyer often drew directly from nature and later reworked the composition in his studio. He generally started out in pencil, went over the contours with pen and ink, and finished the topographical view with watercolor. At times he drew several versions of the same subject.

A. (Anthonie ?) Erkelens

Active ca. 1800

27.
Landscape

Plate IX

Pen and brown ink and watercolor on discolored laid paper; 302 x 490 mm

INSCRIPTION: Signed with pen and brown ink on recto at lower left, *A. Erkelens*

WATERMARK: LD

CONDITION: Some foxing; surface grime; water stains at left edge

PROVENANCE: Paul L. Grigaut, Ann Arbor, Michigan

REFERENCE: Logan 1983, p. 176

Founders Society Purchase, Robert H. Tannahill Foundation Fund (1971.42)

The Detroit drawing is signed by this little-known artist whose landscape studies in color washes are very close to those by Anthonie van Borssom (1629/30–1677). This led most scholars to see in him a seventeenth-century artist, some even placing him among the Rembrandt pupils (see K. Lilienfeld in Thieme and Becker 1907–50, 10: 604, under Pieter van Erkelens). Lugt, in an annotation on a photograph in the RKD, characterized Erkelens's drawings as "similar to Van Borssom but more pointed leaves." (See the excellent up-to-date account on A[nthony?] Erkelens by Ben Broos in Broos 1981, no. 30).

Lugt (1931, p. 49) correctly sensed that Erkelens was more likely an artist active in the second half of the eighteenth century. His opinion was proven correct thanks to a drawing in the collection of Chr. P. van Eeghen that was not only signed *A. Erkelens* but also dated 1801 (Amsterdam 1958, no. 24). The drawing in Detroit may thus be added to the small oeuvre of eleven known sheets first assembled by Pieter Schatborn (Amsterdam 1975–76, no. 36) to which Broos (1981) added another example in the Dyce collection (London 1874, no. 403) at the Victoria and Albert Museum, London. One more drawing by A. Erkelens with a signature identical to that of the Detroit drawing—*A Windmill, Fisherman in a Boat in the Foreground*—was sold at Mak van Waay in Amsterdam (sales cat. no. 260, May 3, 1976, no. 190, ill. p. 164).

Jan Goeree

1670 Middelburg – Amsterdam 1731

28.
Aulus Gellius Finishing Attic Nights,
ca. 1706

Plate X

Pen and brown ink and brown wash, brush and gray ink, and red chalk on buff laid paper; 214 x 168 mm

INSCRIPTION: With pen and brown ink on recto at lower center, *AVLVS GELLIVS / NOCTES ATTICAE / ... / ...GRON... / LVGD:BAT: Apu...Jo...VIVIA / ...SEVERO...*

ANNOTATIONS: With pen and black ink on recto at lower left, *lairesse*; with pencil on recto of mount at lower right, *6fl: 863*; with pencil on verso of mount at lower center, *Sc. 153*; printed entry from a sales catalogue on verso of mount at lower center, *863. Ein Gelehrter in seiner Schreibstube bei Mondschein-beleuchtung; / bezeichnet. Skizze zu dem Titel eines Buches. 4. Sepiazeichnung.*; with pencil on verso of mount at lower center, *L:№ / H. fl. S. D. Währ / Auct: Montmorillon / vom Novbr 1867.*; with

pencil on verso of mount at lower right, *Cat: № 863.*; with pencil on verso of mount at lower left, [indecipherable]; with pen and brown ink on verso of mount at lower center, *№ 3. Gerard Lairesse.*

CONDITION: Traced for transfer; solidly mounted to larger sheet; fold lines

PROVENANCE: Unidentified collector (collector's mark [L. 729] with pen and brown ink on verso at lower left); S. D. Währ; Montmorrillon, sale, November 1867, no. 863 (as Gerard de Lairesse); C. J. Meyer, Carlsbad; James E. Scripps, Detroit, 1887

REFERENCES: Scheyer 1936, no. 85 (as Gerard de Lairesse); Held 1971, pp. 51–54, pl. 21; Cambridge 1980, under no. 4

Gift of Mrs. James E. Scripps (1909.1 S-Dr. 153)

The drawing was made in preparation for the engraved frontispiece of an edition of Aulus Gellius's *Attic Nights* (*Noctes Atticae*; fig. 4), published in Leiden in 1706. This engraving, which reverses the composition of the preliminary design, furnishes us not only with the author's name and the title of the book, but also with the correct name of the draftsman. The design was originally believed to be by Gerard de Lairesse (1640–1711) because of the later annotation at the lower left of the drawing. Julius Held, however, attributed it to Jan Goeree, one of Lairesse's ablest pupils, an attribution based on the inscription on the printed frontispiece: *J.Goeree delin. P. Sluyter fec.*

Held also established the subject matter of the drawing. Goeree represented the Roman lawyer and grammarian Aulus Gellius (A.D. ca. 130–ca. 180) at night seated at a desk and writing by candlelight the last chapter of his best-known book, *Attic Nights*. A full moon illuminates a cityscape in the background, seen through an arched window in the middle distance. The curving platform at the lower center is flanked by Greek coins decorated with the head of Athena at the left and her symbol of an owl at the right.

Gellius started working on this collection of essays during a year's stay in Athens, where he was studying philosophy. He wrote primarily at night, hence the book's title. *Attic Nights* consists of short commentaries on a number of different subjects,

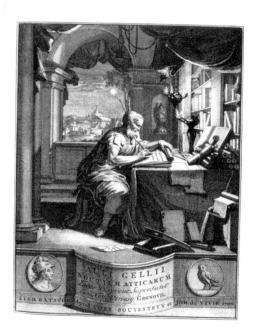

Fig. 4.
Pieter Sluyter, Dutch, active ca. 1700, after Jan Goeree.
Frontispiece for Aulus Gellius' Attic Nights, 1706.
Engraving, 212 x 167 mm. Royal Library, The Hague.
Photo: Royal Library.

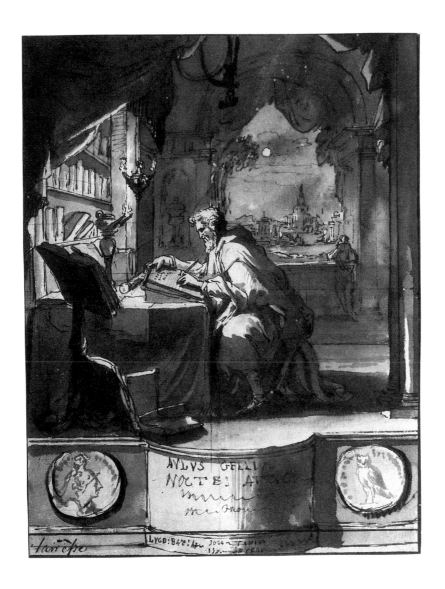

ranging from philosophy and history to language, grammar, and law. Its merit lies above all in furnishing excerpts from little-known works by Roman and Greek authors, which for the most part are no longer extant. *Attic Nights* is divided into twenty books, alluded to in the engraving by the nineteen scrolls on the table and the one Gellius is completing. This last scroll is inscribed in the print, *P. Lavinii / Liber est / non [incuriose factus...]*, which corresponds to the beginning of chapter 11, the last chapter of the twentieth book. The edition of 1706 was of particular interest, since it contained annotations by Johan Frederik and Jakob Gronovius, two humanists asso-

ciated with the University of Leiden. This fact is also indicated in the title page: *AULI GELLII / NOCTIUM ATTICARUM / libri xx prout supersunt / cum notis utriusque GRONOVII / LUGD. BATAVOR....*

The engraving omits the lectern and includes the pile of scrolls instead. The standing figure at the window in the drawing was also eliminated. The city itself is more clearly defined in the print and can be identified as Rome, with the Castel Sant' Angelo dominating the skyline. Since the engraving is dated 1706, we may assume that Goeree drew this frontispiece for *Attic Nights* during or shortly before that year.

Jan van Huysum

1682 Amsterdam 1749

29.

Flowers in an Urn on a Plinth, ca. 1730s

Plate XI

Brush and brown and white gouache over traces of black chalk on buff laid paper; 485 x 367 mm

ANNOTATIONS: With pen and black ink on verso at upper left, *7 [4?]*; with pencil on verso at lower left, *340 - w -*; with black chalk on verso at lower center, *Jan van Huysum*; with pencil on verso at lower left, *N?37.2*; with pencil on verso at lower right, *10.1* [obscured] *.0*

CONDITION: Slight abrasion

PROVENANCE: Sir Charles Greville (black collector's mark [L. 549] on verso at lower left); Earl of Warwick, Warwick (black collector's mark [L. 2600] on recto at lower right); E. Perman, Stockholm; private collection, Amsterdam; Adrian Ward-Jackson, Ltd., London

REFERENCE: *BDIA* 1978/79: 162, ill. p. 163

Founders Society Purchase, Acquisitions Fund (F1979.5)

The use of brown and white gouache over black chalk gives this drawing the appearance of a grisaille sketch. While the urn and the plinth often remain the same throughout Van Huysum's oeuvre, the bouquet of flowers always changes. This composition is dominated by the distinctive form of the crown imperial (*Fritillaria imperialis*). Also identifiable are: tulip (*Tulipa sp.* and the "broken" variety with white streaks); parrot tulip (*Tulipa gesneriana dracontia*); morning glory (*Convolvulus*); apple blossom (*Pyrus malus*); gentian (*Gentiana excisa*); double red peony (*Paeonia festiva*); double pink rose (*Rosa francofurtana*); hollyhock (*Althaea rosea*); larkspur (*Delphinium consolida*); and guelder rose (*Viburnum opulus roseum*). The print room in the British Mu-

seum in London preserves some fifty-three studies in watercolor of individual flowers, plants, and leaves by Van Huysum that he used as a point of reference for his numerous flower pieces (see White 1964, nos. 32–84, where all are reproduced).

Closest to the flower arrangement in the Detroit drawing is that represented in a sheet in the Albertina (White 1964, no. 130), drawn in black chalk alone, which includes a sculptural monument in the distance at the left. Additional drawings, similar but not identical in composition, are in the Louvre (ibid., no. 103) and in the Pierpont Morgan Library, New York. The latter is dated 1737, which may furnish an approximate date for the Detroit drawing as well.

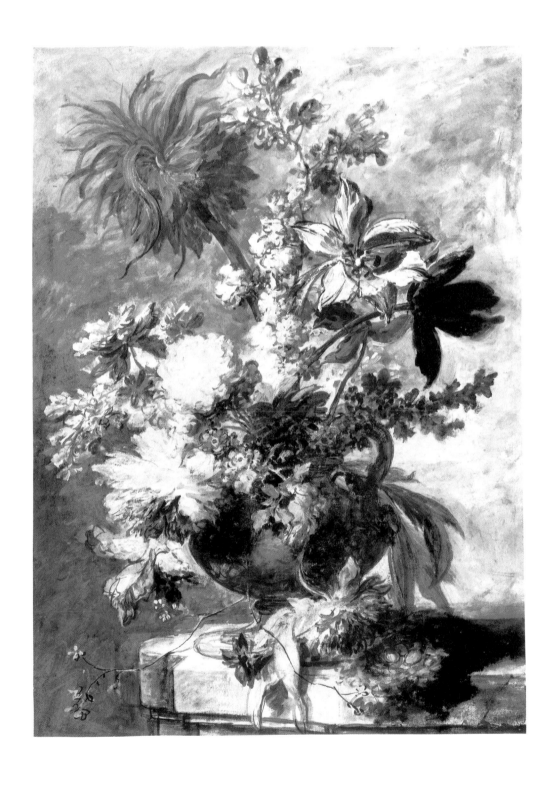

30.
Landscape with Shepherds

Pen and black and gray ink and gray wash on discolored laid paper; 131 x 172 mm

INSCRIPTION: Signed with pen and black ink on recto in center of margin below image, *Jan Van Huijsum fecit.*

ANNOTATIONS: With pencil on verso at upper left, [indecipherable]; with pencil on verso at left, *Jan Van Huysum / 1682–1749*; with pencil on verso at center, *269*

WATERMARK: Indecipherable fragment at lower edge

CONDITION: Inlaid to another paper with decorated borders

PROVENANCE: Unidentified collector (black collector's mark on recto at lower right); E. Speelman, London

REFERENCES: *BDIA* 1935: 57; Scheyer 1936, no. 83

Founders Society Purchase, William H. Murphy Fund (1934.96)

Jan van Huijsum, as he preferred to sign his name, is better known for his flower pieces than for his arcadian landscapes, of which this is a characteristic example. Tightly composed and drawn with a fine pen in a very short stroke, they evoke the Neoclassical tradition more closely associated with Isaac de Moucheron (1667–1744). The tree-filled landscape, furthermore, with its view of a city in the middle distance and a mountain in the far distance, together with the arcadian figures reclining in the foreground, recalls Claude Lorrain (1600–1682).

Related drawings are in the Musée Wicar, Lille (inv. 1010; photo, Gernsheim 18 504), and in Berlin (inv. 2812; Bock and Rosenberg 1930, p. 162).

Jacobus van Liender

1731 Utrecht 1797

31.
Edge of the Woods, ca. 1780s

Black chalk, brush and gray and black ink, and gray wash on discolored laid paper; 412 x 352 mm

ANNOTATIONS: With pencil on verso at center, *N.° 14* [crossed out] and *No. 10*

WATERMARK: Coat of arms (cf. Heawood 515)

CONDITION: Mat burn; tear top center; crease upper left corner

PROVENANCE: Lili Froehlich-Bum, London; Schaeffer Galleries, Inc., New York; John S. Newberry, Grosse Pointe Farms, Michigan, 1948

EXHIBITION: Detroit 1965 (as Jan Hackaert)

REFERENCES: *BDIA* 1950/51: 52 (as Jan Hackaert); Detroit 1965, p. 44 (as Jan Hackaert)

Gift of John S. Newberry (1950.252)

The former attribution to Jan Hackaert (1636–1699) was changed by J. Nieuwstraten, who recognized the drawing as a late eighteenth-century work (letter to Dewey Mosby, April 7, 1976; Curatorial Files) and suggested Jacobus van Liender as the artist. There are two signed and dated drawings by Van Liender that are similar in execution to the Detroit sheet: one, of 1785, in the De Grez collection, Brussels (photo ACL 1739 28B); the other, of 1789, in the Teyler Foundation, Haarlem (Minneapolis 1971, no. 41, pl. 84). The drawing under discussion seems to date from the same years, i.e., 1780–90.

Cornelis Troost

1697 Amsterdam 1750

32.
The Fishing Party, 1738

Plate XII

Black chalk, pen and brown ink, and gray wash on discolored laid paper; 313 x 235 mm

INSCRIPTION: Signed and dated with pen and black ink on recto at lower right, *C. Troost. / 1738*

ANNOTATION: With pencil on verso in upper right corner, *3*

WATERMARK: IV

CONDITION: Foxing; creasing at upper right with loss of medium

PROVENANCE: Frederic A. Stern, New York

EXHIBITIONS: Montreal 1944, no. 91; Winnipeg 1952, no. 37; Minneapolis 1961, no. 92

REFERENCES: Newberry 1946, p. 18, ill.; De Morinni 1956, p. 52, ill.; Niemeijer 1973, p. 384, no. 843T, ill.

Gift of Frederic A. Stern (1945.419)

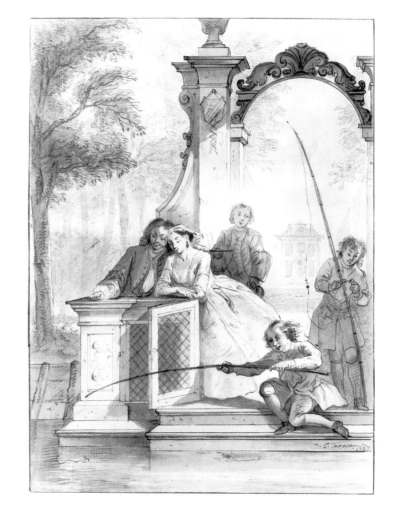

Troost represented a young, elegantly dressed couple standing in front of an elaborate gate while two boys fish and a servant brings refreshments. The subject derives from a seventeenth-century tradition whereby fishing was often synonymous with love. The inclusion of a young couple in the composition supports this interpretation. A very similar theme is found in Pieter Cornelisz. Hooft's (1581–1647) well-known emblem book, the *Emblemata amatoria* of 1611, where a cupid is seen fishing while a couple promenades in the middle distance. We may, therefore, surmise that the youths trying to catch a fish are like the lovers trying to "catch" each other (for further treatment of the subject, see Amsterdam 1976a, no. 46).

The drawing belongs to Troost's mature period. Since it is signed and dated at the lower right, and since a coat of arms is faintly indicated on the pillar of the gate, we may surmise that it was commissioned and conceived as an independent work of art.

A. P. Vorenkamp thought Troost represented a house on the river Vecht, southeast of Amsterdam, in the province of Utrecht (letter to E. P. Richardson, September 25, 1945; Curatorial Files).

Jacob de Wit

1695 Amsterdam 1754

33.

Apollo Enthroned with Minerva and the Muses, 1730

Plate XIII

Pen and gray ink, brush and brown and black ink, and gray, brown, and red wash, heightened with white and pink, over a preliminary drawing in graphite on discolored laid paper; 326 x 278 mm

INSCRIPTIONS: Signed with pen and brown ink on recto at lower left, *J de Wit invt* [*JdeW* in monogram]; with pen and brown ink on verso at lower center, *Blaffon / voor de Heer direk van Lennip 1730— op eynde Edzzaal / geschildert*; with pencil on verso at lower center, *+ 1500*

WATERMARK: Strasbourg lily (cf. Churchill 411)

CONDITION: Repaired tears left edge and right top edge; abrasion of image in dark areas; white lead and pink discoloration

PROVENANCE: Schaeffer Galleries, Inc., New York

REFERENCES: Staring 1959, pp. 56–58, fig. 4 (wrongly listed as in an Amsterdam collection); De Bruijn Kops 1982, pp. 52–59, fig. 3

Founders Society Purchase, Elizabeth P. Kirby Fund (1958.208)

Apollo with his lyre is seated on clouds in the center, while Minerva, clad in armor as protector of the arts, stands at his side. They are surrounded by the nine Muses, who are identified thanks to annotations found on another preliminary design by De Wit in Berlin (see below). They are, beginning at top left: Urania (astronomy), with a globe; Euterpe (music), with a flute; Terpsichore (dancing and choral song), seen from the back and holding a lyre; Calliope (eloquence and heroic poetry), holding an open book and turning toward Terpsichore; Thalia (comedy and bucolic poetry), with a staff; Clio (history), in a helmet and holding a large volume; and Melpomene (tragedy), lost in thought; with Erato (lyric and amorous poetry) playing the violin at top right. The ninth Muse, Polyhymnia (sacred lyric), is not found in the Detroit drawing but is included in the later drawing in Berlin, where De Wit inserted her at bottom center, as well as in the ceiling painting in Amsterdam.

This is the earlier of two known designs by De Wit for the ceiling painting commissioned by Dirk van der Meer (1686–1738) in 1730 for his house, called "Marseille," at Keizersgracht 401 in Amsterdam. From an inscription on the verso of a drawing in a private collection in Amsterdam that De Wit erroneously identified with the design in Detroit,

i.e., for Dirk van der Meer (instead of the one for Dirk van Lennep, to whom the inscription on the verso of the present drawing refers), we learn that this commission was to paint a ceiling for a side-room and was executed in 1730 (*Blaffon voor den Edl Heer derck van der Meer in sijne Edls sijkamer 1730 geschildert*). Dirk van der Meer was a merchant trading with Italy, the Orient, and Curaçao, who had taken over his father's trading company. After the latter's death in 1729, he inherited the house and the following year commissioned a ceiling decoration from Jacob de Wit. This ceiling painting (figs. 5a, b) has been in the Rijksmuseum in Amsterdam since

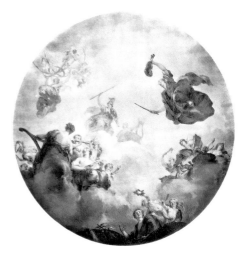

Fig. 5a.
Jacob de Wit. *Apollo, Minerva, and the Muses*, 1731 (before cleaning). Oil on canvas, diam. 427 cm. Rijksmuseum, Amsterdam, on loan from the Koninklijk Oudheidkundig Genootschap (inv. C1221). Photo: Rijksmuseum.

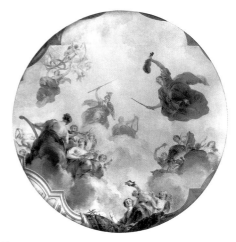

Fig. 5b.
Apollo, Minerva, and the Muses (after cleaning). Diam. 436 cm. Photo: Rijksmuseum.

1932, on loan from the Royal Antiquarian Society (Koninklijk Oudheidkundig Genootschap; see Amsterdam 1976, p. 608, no. C 1221, ill. For a study of the painting after its restoration and the two preliminary drawings see De Bruijn Kops 1982, pp. 52–59).

The so-called "sideroom" mentioned in De Wit's inscription can no longer be identified in the original house on the Keizersgracht because of later alterations, as De Bruijn Kops pointed out. It must have been a rather spacious room in order to accommodate the painting that originally may have measured as much as five and one-half by six meters. For that same room De Wit apparently also made a painting in gray of *Aurora Receiving Immortality for Her Beloved Tithonos*, which may have served as a chimney piece. A preliminary drawing by De Wit with his inscription was sold by R. W. P. de Vries on June 24, 1914 (see Staring 1958, p. 147: *Aurora verkrijgt de onsterfelijkheid voor Tiron* [Tithonos] *haer m* [innaar] *voor dEdl Derck van der Meer scheepen der Stadt Amsterdam in syn Edls Sycaemer int grauw* [Aurora obtains immortality for Tithonos, her lover, for Derck van der Meer, alderman of the city of Amsterdam in his sideroom, in gray]).

Between the drawing in Detroit and the painting now on loan to the Rijksmuseum, De Wit made another, more developed, preliminary study now in Berlin (fig. 6; see Bock and Rosenberg 1930, p. 321, no. 14578). In contrast to the study in Detroit, which is of a rectangular format with canted corners, De Wit next surrounded the composition with a balustrade, arranged in a quatrefoil and more spread out vertically. New is the group at bottom center with Polyhymnia and a winged horse (Pegasus), as well as a large drapery placed over the balustrade. This group, without the horse, is taken over into the painting. The staff of Mercury and the Turkish carpet were references to Van der Meer's trade with the Orient.

The painting itself was cleaned in 1981 and De Wit's signature and the date *1731* were discovered at the right of the carpet draped over the balustrade. The restoration also revealed part of a balustrade that had been painted out. The overall format is round and may possibly have been cut down.

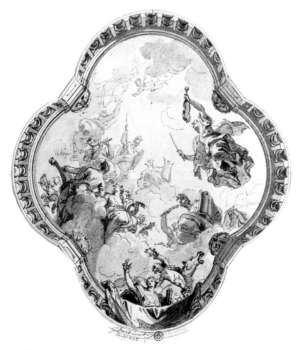

Fig. 6.
Jacob de Wit. *Apollo, Minerva, and the Muses*, 1731. Pen and brown ink and brown wash, heightened with white, 262 x 230 mm. Staatliche Museen, Preussischer Kulturbesitz, Kupferstichkabinett, Berlin-Dahlem. Photo: Jörg P. Anders, Berlin.

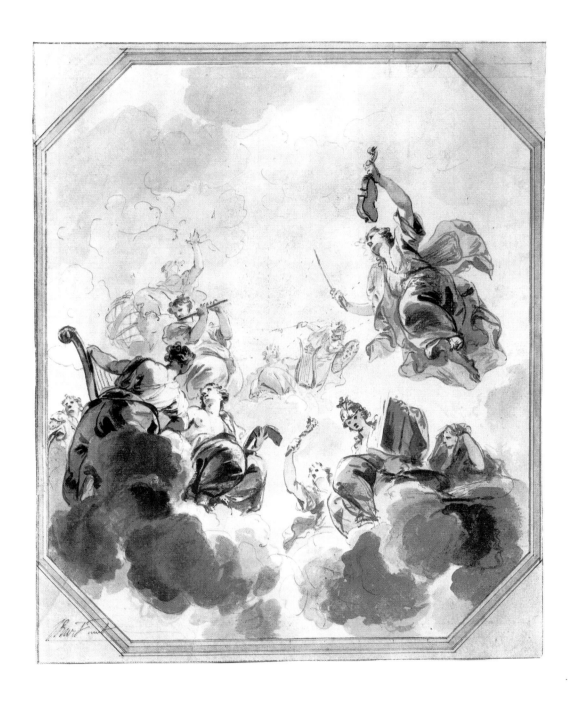

Josef Israëls

1824 Groningen – The Hague 1911

34.
*Mother Feeding Her Baby
(The Cottage Madonna)*, ca. 1900

Black chalk on artist's illustration board;
394 x 278 mm

INSCRIPTION: Signed with black chalk on recto at
lower left, *With my compliments / to miss Nell
Ford / Josef Israëls*

CONDITION: Some smudging of image; stains both
upper corners

PROVENANCE: Nell Ford Torrey, Detroit

REFERENCES: Eisler 1924, pl. XVI; *BDIA* 1959/60: 44

Bequest of Nell Ford Torrey (1959.118)

This drawing of a mother feeding her child relates closely to Israëls's so-called *Cottage Madonna*, painted about 1867, also in the Detroit Institute of Arts (fig. 7; see Paris 1983, cat. 32, color ill.). The subject matter recalls a favorite theme of Dutch painters of the seventeenth century, such as Pieter de Hooch (1629– ca. 1684), Gabriel Metsu (1629–1667),

and Gerard Terborch (see cat. nos. 21 and 22). The drawing is very summary and appears to be a later *ricordo*, that is, a drawing Israëls made especially for Miss Nell Ford, as the dedication indicates, most likely when she purchased the painting for her collection sometime around the turn of the century.

Fig. 7.
Josef Israëls. *The Cottage Madonna*, ca. 1867. Oil on canvas, 134.6 x 99.7 cm. Bequest of Nell Ford Torrey (59.117). Photo: The Detroit Institute of Arts.

Johan Barthold Jongkind

1819 Lattrop, Holland — Côte-Saint-André, France 1891

35.
Road Leading into a Village (recto),
ca. 1855
Houses with a View into the Distance
(verso), 1888

Black chalk, watercolor, and gouache on white wove paper; 111 x 194 mm

INSCRIPTIONS: Dated with brush and purple blue ink on verso at lower right, *22 Aout 1888*; with charcoal on verso at upper left, *bleu* [twice]

ANNOTATION: With pen and brown ink on recto at lower right, *443*

CONDITION: Considerable transfer of media, probably from other drawings in the sketchbook; discoloration and adhesive residue at edges

PROVENANCE: Estate of the artist (black artist's estate stamp [L. 1401] on recto at lower right); Helen Pitts Parker, Grosse Pointe, Michigan

REFERENCE: Detroit 1967, p. 63

Gift of Mrs. Arthur Maxwell Parker (1953.339)

Fig. 8.
Johan Barthold Jongkind. *Road Leading into a Village,* 1861. Oil on canvas, 42 x 57 cm. Rijksbureau voor Kunsthistorische Documentatie, The Hague. Photo: RKD.

The sheet probably once was part of a sketchbook that Jongkind had used for many years, since the recto and verso date some thirty years apart. The recto, representing a road leading into a village in snow with a church at the left, is related to a painting (fig. 8) by Jongkind of the same subject, signed and dated 1861, in a private collection in Switzerland (Hefting 1975, no. 211; Sotheby's, London, sales cat., June 28, 1976, no. 13, color ill.). Another drawing, from almost the same viewpoint, is in the Louvre (Moreau-Nélaton 1918, fig. 1). Hefting tentatively identified the village as Klaaswaal, situated in southern Holland west of Dordrecht. By 1861, however, Jongkind no longer lived in Holland but in Paris, on the rue de Chevreuse. The sketchbook study, there-

fore, dates from an earlier time, possibly ca. 1855, when Jongkind painted another view of Klaaswaal taken from the opposite side with the church at the right (Hefting 1975, no. 132, ill.).

The verso of the sketchbook sheet, dated August 22, 1888, is one of Jongkind's last drawings. It probably represents a view in the countryside of Côte-Saint-André, a French village situated between Lyons and Grenoble, where the artist spent his summers from 1878 onward. During those late years, Jongkind worked almost exclusively in watercolor.

Dr. Victorine Hefting kindly discussed the Detroit drawings by or after Jongkind (see nos. 36, 37, A12, and A13) with the author in The Hague, 1977.

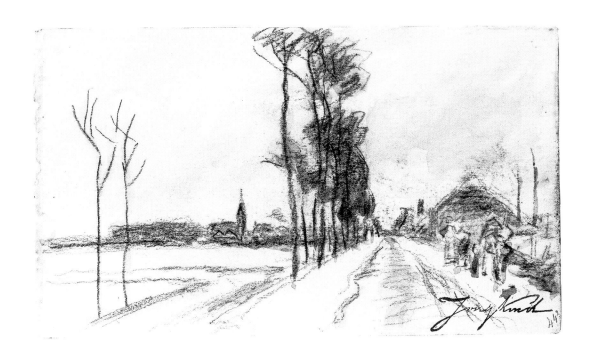

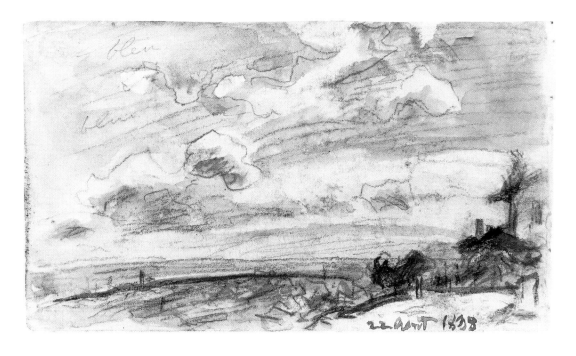

36.
View of Overschie, ca. 1856–60

Carbon pencil on off-white wove paper;
221 x 310 mm

ANNOTATION: With pen and brown ink on recto at
lower right, *262*

CONDITION: Discoloration; foxing; sewing marks at
left indicate sheet may be from a sketchbook; traces
of another sketch offset on verso

PROVENANCE: Estate of the artist (artist's estate
stamp [L. 1401] on recto at lower right); Henri Petit,
Paris; Mr. and Mrs. Bernard F. Walker, Bloomfield
Hills, Michigan, 1960

REFERENCE: Detroit 1961, p. 24

Gift of Mr. and Mrs. Bernard F. Walker (F1981.426)

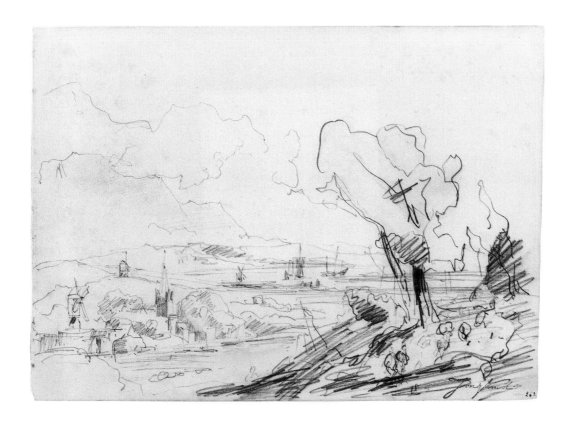

Overschie is a suburb to the northwest of Rotterdam in the southern part of Holland. Jongkind stayed there in the house of his niece, Wilhelmina Jacoba Jongkind, who was married to Johannes Frings, a house painter. The family lived along the river Schie next to the church. Jongkind often sketched from a small boat on the river. According to Dr. Victorine Hefting, who kindly identified the scenery (letter to the author, August 1987; Curatorial Files), this wide view over windmills and an estuary of the river may be seen from the top of a small hill near the church.

Jongkind's first stay in Overschie with the Frings family was in 1856. Paintings, watercolors, and drawings representing the town and its surroundings are numerous and recur almost every year from 1856 to 1887. The drawing probably belongs to Jongkind's early studies of Overschie and dates from ca. 1856–60.

The sewing marks at the left indicate that the sheet probably was part of a sketchbook. Numbers similar to the one at bottom right are also found on Jongkind drawings in the Louvre (see, for example, Hefting 1975, nos. 161, 206, 279, 445, 488, and others).

37.
Boats on a River, 1885

Plate XIV

Black chalk, watercolor, and gouache on discolored wove paper; 119 x 181 mm

INSCRIPTION: Signed and dated with brush and blue ink on recto at lower left, *Jongkind 1885*

ANNOTATIONS: With black chalk on verso at left, *Envoyer mercredi 21 Juillet 86 à M. D. Doart* [?]; with pencil on verso at right, *26 x 32 / 5 x 50*

CONDITION: Abrasion at edges; repaired lower left corner; some crackle and losses to pigment at lower left

PROVENANCE: Alexandre Arsène, Paris, sale, May 18–19, 1903, no. 96; Georges Petit, Paris, sale, March 4–5, 1921, no. 22; Helen Pitts Parker, Grosse Pointe, Michigan

EXHIBITION: Holland 1982

REFERENCE: Detroit 1967, p. 63

Gift of Mrs. Arthur Maxwell Parker (1953.340)

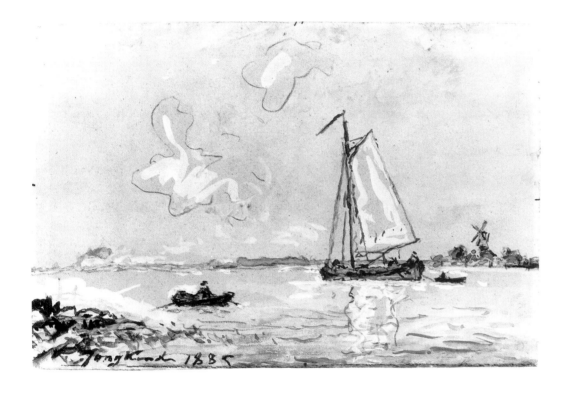

This late watercolor by Jongkind, executed in 1885 when the artist had been living in France for almost twenty years, is nonetheless composed of Dutch motifs, such as the large sailboat in the foreground and the windmill at the right. Jongkind must have made the sketch either from memory or based it on an earlier drawing, because there is a signed and dated watercolor (*Dort 11 oct 69*) in the Louvre of a similar scene on the canal near Dordrecht: an identical sailboat flanked by two smaller rowboats and a mill silhouetted against the sky. The latter composition also was used for a painting, dated 1873, in a private collection (Hefting 1975, nos. 516, 596, ill.). This working procedure of taking up earlier compositions and reusing them for paintings and drawings was not uncommon for Jongkind. He painted very little during his last years, however, and no late painting of his with the subject of this drawing is known.

Jacobus van der Stok

1794/95 Leiden – Amsterdam 1864

38.
River Scene

Brush and brown ink and brown wash over a preliminary drawing in black chalk on cream laid paper; 149 x 204 mm

INSCRIPTION: Signed with brush and brown ink on recto at lower left, *Stok F.*

ANNOTATIONS: With pencil on verso at lower left, *J. van der Stok*; with pencil on verso at lower center, *C 3754*

CONDITION: Discoloration

PROVENANCE: Lillian Henkel Haass, Detroit

REFERENCE: *BDIA* 1941: 47

Gift of Lillian Henkel Haass (1940.160)

This signed drawing of a Dutch river scene is a characteristic work of Van der Stok, who is best known for his landscapes.

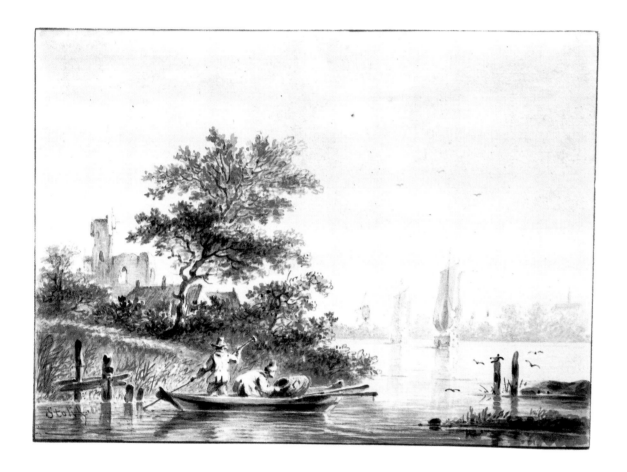

Carel Nicolaas Storm van 's Gravesande

1841 Breda – The Hague 1924

In 1868, a year after having passed the bar exam, Storm van 's Gravesande decided to forego the legal profession and become an artist. These seventeen drawings in black chalk and in watercolor date from 1870 to the late 1880s and record the first twenty years of the artist's working progress. Many of the drawings depict the characteristic Dutch landscape of dunes or canals with sailboats in the foreground, windmills or church towers in the distance. Storm van 's Gravesande's favorite spots were Dordrecht and its vicinity, the shallow waters of the Biesbosch, and the dunes around Katwijk. The airy, loose atmosphere in the watercolors is indebted to the work of the better-known Dutch artist Jongkind (see cat. nos. 35–37, A12, and A13).

The following seventeen drawings and watercolors were presented to the Detroit Institute of Arts in 1905 by Charles L. Freer, together with approximately 400 prints by the same artist. Eight of these drawings were already in Freer's collection by 1889, that is, shortly after they were executed, since they were included in that year in the exhibition at Frederick Keppel & Co. in New York to which Freer lent fourteen drawings and eight prints. The eight watercolors and drawings lent by Freer are: *My Studio*, *Zwijndrecht*, two views of *The Maas off Dordrecht*, *Fishing Boats*, *In the Downs*, *Corner of My Garden*, and *The Downs near Katwijk*.

Since the latest date found on two of these sheets is 1887 and *On the Vecht* bears a dedication to Freer, we may assume that the drawings were probably acquired in about 1888 directly from the artist.

Storm van 's Gravesande reproduced in etchings a number of his drawings now in Detroit. The earliest print that is based on a drawing in Detroit (cat. no. 40) is the *View of Deventer Taken from the Outskirts* (New York 1889, no. 21), dated 1870. Another drawing, *Entrance to a Forest near Kelheim* (cat. no. 43), dated 1871, was used for an etching that was part of his first series of thirteen prints published in 1872. Prints were also made after the drawings *Along the River Gein* (cat. no. 39), *Canal near Rijnsburg* (cat. no. 46), *On the Vecht* (cat. no. 52), and *The Herring Fleet, Katwijk* (cat. no. 55). For further information regarding the body of Storm van 's Gravesande's prints, see *The Print Council Index to Oeuvre-Catalogues of Prints by European and American Artists*, compiled by Timothy A. Riggs (Millwood, New York; London; and Schaan, Liechtenstein: Kraus International Publications, 1983), pp. 739–740.

39.
Along the River Gein

Black chalk over a preliminary drawing in graphite pencil on discolored wove paper; 304 x 474 mm

INSCRIPTION: Signed with black chalk on recto at lower right, *CN Storm van 's Gravesande.*

CONDITION: Lined with paper and fabric

PROVENANCE: Charles L. Freer, Detroit

REFERENCE: Detroit 1967, p. 49

Gift of Charles L. Freer (1905.398)

This drawing was reproduced in an etching titled *Windmill on the River Gein* (New York 1889, no. 184), which is also in the Detroit Institute of Arts (1905.197).

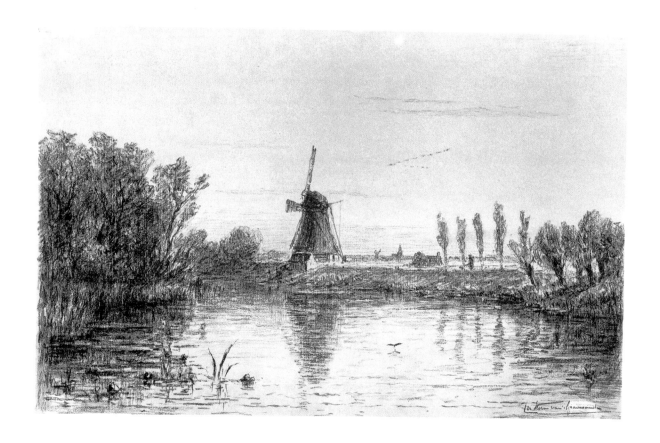

40.
View of Deventer Taken from the Outskirts, 1870

Watercolor over graphite on discolored wove paper; 211 x 290 mm

INSCRIPTIONS: Signed and dated with brush and brown ink on recto at lower right, *CN Storm van 's Gravesande 1870.*; with black chalk on verso at lower center, *In de voorstad (Deventer)*

ANNOTATIONS: With black chalk on verso at upper left, *8* [in circle and crossed out]; with black chalk on verso at upper left, *No 5*; with black chalk on verso at lower center, *In the suburbs of Deventer (1870)*;

with pencil on verso at lower center, *drawing for Etching. No. 21*; with pencil on verso in lower right corner, *No 70* [partially erased]

CONDITION: Faint mat burn; scattered accretions; surface grime

PROVENANCE: Charles L. Freer, Detroit

REFERENCE: Detroit 1967, p. 49

Gift of Charles L. Freer (1905.6)

This is the earliest drawing by Storm van 's Gravesande in Detroit. It was reproduced in an etching with the title *View of Deventer Taken from the Out-* *skirts* (New York 1889, no. 21), also in Detroit (1905.28). The town of Deventer is in the eastern part of Holland, near Apeldoorn.

41.
Corner of My Garden

Charcoal and black chalk on discolored wove paper;
325 x 240 mm

INSCRIPTIONS: Signed with black chalk on recto at
lower right, *SG* [in monogram]; with black chalk on
verso at lower left, *My garden*; with black chalk on
verso in lower left corner, *70*

ANNOTATION: With pencil on verso in lower right
corner, *Wxᵛˣ*

CONDITION: Large repaired tear across lower left

PROVENANCE: Charles L. Freer, Detroit

EXHIBITION: New York 1889, no. 70

REFERENCE: Detroit 1967, p. 49

Gift of Charles L. Freer (1905.394)

Storm van 's Gravesande most likely sketched this
view into his garden from the window of his studio
on the second floor of his house in the Rue du Trône
in Brussels. For a rendering of his studio see cat. no. 50.

42.
The Downs near Katwijk

Watercolor over a preliminary drawing in black chalk on discolored wove paper; 238 x 333 mm

INSCRIPTIONS: Signed with pencil on recto at lower right, *CN Storm van 's Gravesande*; with brush and brown watercolor on recto at lower left, *Katwijk*; with brush and black watercolor on verso at lower left, *99*

ANNOTATIONS: With red chalk on verso at upper left, *No 5* [crossed out with pencil]; with pencil on verso at upper left, *No. 6.*; with pencil on verso in lower right corner, *Wx^vx*

CONDITION: Surface grime; small tears at top edge

PROVENANCE: Charles L. Freer, Detroit

EXHIBITION: New York 1889, no. 99

REFERENCE: Detroit 1967, p. 49

Gift of Charles L. Freer (1905.7)

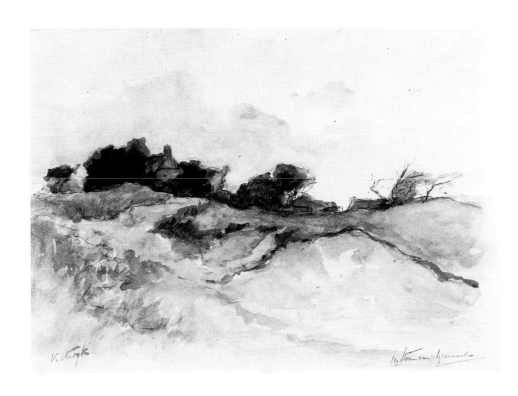

43.
Entrance to a Forest near Kelheim, 1871

Black chalk on blue wove paper; 330 x 505 mm

INSCRIPTIONS: Signed with black chalk on recto at lower left, *CN Storm van 's* <u>*Gravesande*</u>; with pen and red ink on recto at lower right, *'s Gravesande ft / 1871*; signed with charcoal on verso at lower right but erased through abrasion

ANNOTATIONS: With pencil on verso at lower left, *van Gravesande / charcoal drawing / Entrance to forest-/*; with pencil on verso at lower center, *78270*; with pencil on verso at lower right, *Fyx* [indecipherable]

CONDITION: Edges worn; tears

PROVENANCE: Charles L. Freer

REFERENCE: Detroit 1967, p. 49

Gift of Charles L. Freer (1905.397)

The drawing closely relates to the etching in reverse with the title *Entrance to a Forest near Kelheim* (New York 1889, no. 25). Kelheim is in Bavaria, southwest of Regensburg, on the river Altmuhl shortly before it flows into the Danube. The print is preserved in the Detroit Institute of Arts collections (1905.32–33).

44.
Fishing Boats

Charcoal and black chalk on blue wove paper;
494 x 327 mm

INSCRIPTIONS: Signed with charcoal on recto at
lower left, *SG* [in monogram]; with charcoal on verso
at lower left, *N° 17*.

ANNOTATIONS: With pencil on verso in center, *4227*;
with pencil on verso in lower right corner, *Fxvˣᵛ*

CONDITION: Discoloration

PROVENANCE: Charles L. Freer, Detroit

EXHIBITION: New York 1889, no. 17

REFERENCE: Detroit 1967, p. 49

Gift of Charles L. Freer (1905.393)

45.
In the Downs, 1885(?)

Watercolor over a preliminary drawing in black chalk on discolored wove paper; 212 x 325 mm

INSCRIPTIONS: Signed with brush and gray ink on recto at lower right, *CN Storm van 's Gravesande*; with black chalk on verso at lower left, *bij Katwijk 85*

ANNOTATIONS: With red chalk on verso at upper left, *No 3* [crossed out with black chalk]; with black chalk on verso at upper left, *No 8*; with black chalk on verso in lower left corner, *54*; with black chalk on verso at lower left, *In the downs*; with pencil on verso at lower right, *ox^{vn}*

CONDITION: Stain and graphite pencil mark in upper left corner

PROVENANCE: Charles L. Freer, Detroit

EXHIBITION: New York 1889, no. 54

REFERENCE: Detroit 1967, p. 49

Gift of Charles L. Freer (1905.9)

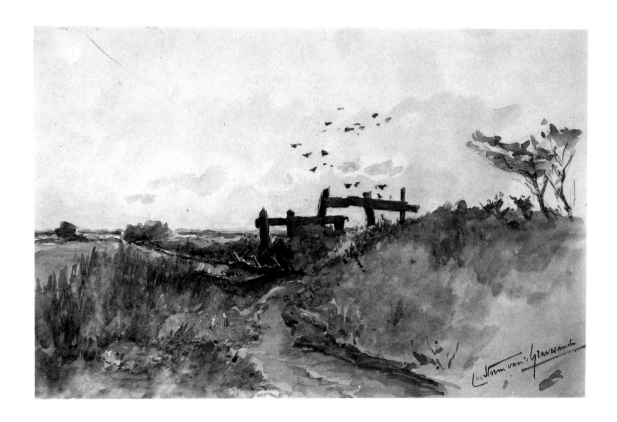

46.
Canal near Rijnsburg, 1885

Watercolor and black chalk on discolored wove paper; 162 x 333 mm

INSCRIPTIONS: Signed with brush and watercolor on recto at lower left, *CN Storm van 's Gravesande*; with chalk on verso at lower left, *bij Rijnsburg 85*

ANNOTATIONS: With red chalk on verso at upper left, *No 6* [crossed out]; with black chalk on verso at upper left, *No 7*; with pencil on verso at lower left, *Canale near Rijnsburg / sketch for etching 229*

CONDITION: Surface grime

PROVENANCE: Charles L. Freer, Detroit

REFERENCE: Detroit 1967, p. 49

Gift of Charles L. Freer (1905.8)

The drawing was reproduced in an etching in reverse (New York 1889, no. 229) of the same title, also in Detroit (1905.247). Rijnsburg lies between Leiden and Katwijk.

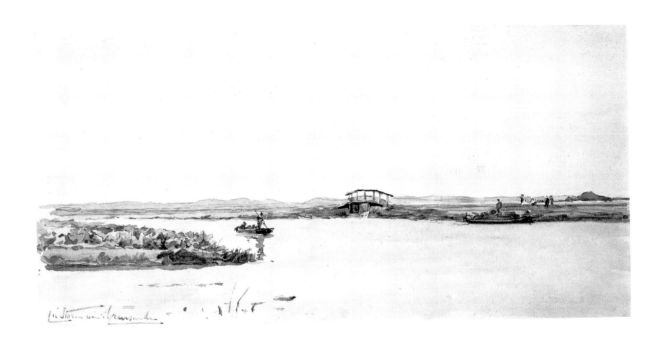

47.
The Maas near Rotterdam

Watercolor over traces of charcoal on white wove paper; 210 x 353 mm

INSCRIPTION: Signed with brush and gray ink on recto at lower right, *SG* [in monogram]

ANNOTATIONS: With black chalk on verso at lower center, *Meuse off Rotterdam (early/Morning)*; with pencil on verso at lower right, *N° 10* [between two horizontal lines]

WATERMARK: J. What[man]

CONDITION: Some abrasion along lower edge; slight discoloration

PROVENANCE: Charles L. Freer, Detroit

REFERENCE: Detroit 1967, p. 49

Gift of Charles L. Freer (1905.10)

48.
The Maas off Dordrecht (recto)
Sketch of a Building and a Tree (verso)

Watercolor over a preliminary drawing in graphite pencil (recto), graphite pencil (verso), on white wove paper; 355 x 508 mm, 110 x 100 mm (image, verso)

INSCRIPTIONS: Signed with brush and watercolor on recto at lower right, *CN Storm van 's Gravesande*; with brush and watercolor on verso at lower left, *№ 12*.

ANNOTATIONS: With red chalk on verso at upper left, *No 12*, and over it, *11* [crossed out with pencil]; with pencil on verso at upper left, *No-1*; with pencil on verso at lower left, *No. 12*; with pencil on verso in lower right corner, *Fxv* [indecipherable]

CONDITION: Slight discoloration; surface grime

PROVENANCE: Charles L. Freer, Detroit

EXHIBITION: New York 1889, no. 12

REFERENCE: Detroit 1967, p. 49

Gift of Charles L. Freer (1905.2)

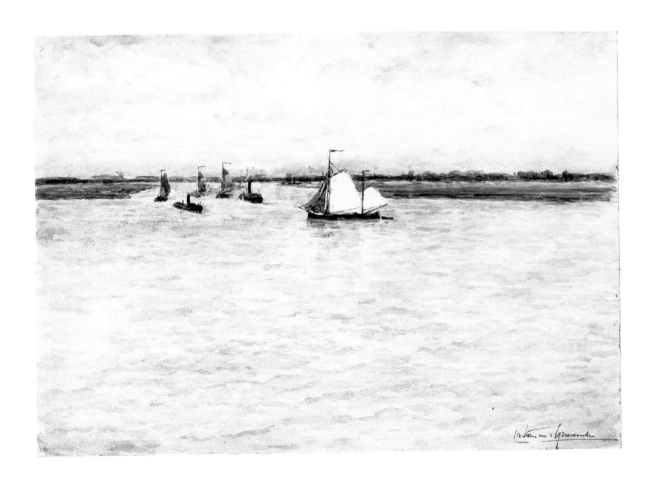

Sketch of a Building and a Tree (verso, cat no. 48)

49.
The Maas off Dordrecht, 1885

Plate XV

Watercolor on white wove paper; 296 x 444 mm

INSCRIPTIONS: Signed and dated with brush and
dark gray ink on recto at lower right, *CN Storm van
's Gravesande 85*; with brush and watercolor on
verso at lower left, *80*; with pencil on verso at lower
center, *Op de Maas voor Dordrecht*

ANNOTATIONS: With red chalk and pencil on verso
at upper left, *No 4* [crossed out with pencil]; with
pencil on verso at upper left, *No 2*; with blue chalk
on verso at center, *647*; with pencil on verso at lower
left, *No 4*; with pencil on verso at lower center, *"The
Red Nosed Boat"* [partially erased]; with pencil on
verso in lower right corner, *FHXvx*

CONDITION: Some discoloration

PROVENANCE: Charles L. Freer, Detroit

EXHIBITION: New York 1889, no. 80

REFERENCE: Detroit 1967, p. 49

Gift of Charles L. Freer (1905.3)

50.
My Studio

Charcoal and black crayon over a preliminary drawing in graphite pencil on the verso of an etching on cream wove paper; 465 x 607 mm

INSCRIPTIONS: Signed in red ink on recto at lower right, *CN Storm van 's Gravesande;* with black crayon on recto at lower right, *SG* [in monogram]

ANNOTATIONS: With pencil on verso at upper right, *4225;* with black chalk on verso in lower left corner, *3;* with pencil on verso in lower right corner, *Fox*vx

CONDITION: Yellowed

PROVENANCE: Charles L. Freer, Detroit

EXHIBITION: New York 1889, no. 3

REFERENCE: Detroit 1967, p. 49

Gift of Charles L. Freer (1905.392)

In his introduction to the catalogue of the 1889 exhibition in New York of Storm van 's Gravesande's drawings and prints, Richard A. Rice, then professor at Williams College in Williamstown, Massachusetts, briefly recounts his visit to the artist's house in Brussels in the summer of 1887:

> From its rather grim-looking exterior one is hardly prepared for the friendly interior, which is neither Belgian nor Dutch, but simply artistic, in the sense that it suggests at once the presence of a man whose life is in art. The glare of that interminable street, the "Rue du Trône," made the outlook into the pleasant gardens, of which there

are three fine drawings [among them one now in Detroit, cat. no. 41], a great relief. We sat by the open window and caught the sweet scents while we talked of art and artists. . . .

Rice continued that Storm van 's Gravesande's studio, represented in the present drawing, was on the upper floor. Here the artist apparently made his etchings. The view through the window seems to reflect the same scenery found in his drawing *Corner of My Garden* (see cat. no. 41). According to Rice, Storm van 's Gravesande painted in another studio, situated at some distance from the house on the Rue du Trône, in a room on the ground floor.

51.
On the River Gein

Charcoal and black chalk on discolored wove paper;
362 x 422 mm

INSCRIPTION: Signed with black chalk on recto at
lower left, *CN Storm van 's Gravesande*

CONDITION: Solidly mounted to board

PROVENANCE: Charles L. Freer, Detroit

REFERENCE: Detroit 1967, p. 49

Gift of Charles L. Freer (1905.395)

52.
On the Vecht

Charcoal and black chalk on discolored wove paper;
332 x 474 mm

INSCRIPTIONS: Signed with charcoal on recto at
lower right, *CN Storm van 's Gravesande*; with char-
coal on recto at lower left, *For C. L. Freer Esq.*[re]

CONDITION: Lined with paper and fabric

PROVENANCE: Charles L. Freer, Detroit

REFERENCE: Detroit 1967, p. 49

Gift of Charles L. Freer (1905.396)

This drawing was reproduced in an etching with the
title *The River Vecht near Weesp*, which was pub-
lished by Frederick Keppel (New York 1889, no. 251).
The print is also in Detroit (1905.270). Weesp is a
short distance to the southeast of Amsterdam.

53.
Ships near Dordrecht, 1887

Watercolor and black chalk on white wove paper;
225 x 286 mm

INSCRIPTION: Signed and dated with brush and
watercolor on recto at lower left, *Dordrecht 87 / CN
Storm van 's Gravesande*

ANNOTATIONS: With red chalk on verso at upper
left, *4* [in circle], with black chalk over it, *7* [crossed
out]; with black chalk on verso at upper left, *No 3*;
with pencil on verso at lower center, *32*; with black
chalk on verso at lower left, *"On the Maas"*

CONDITION: Slight staining at top edge; surface
grime

PROVENANCE: Charles L. Freer, Detroit

REFERENCE: Detroit 1967, p. 49

Gift of Charles L. Freer (1905.4)

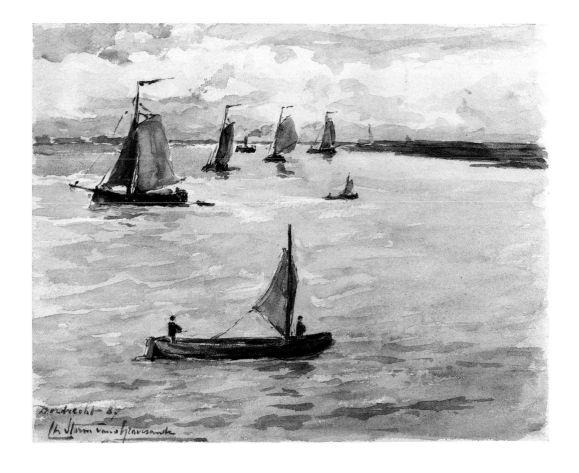

54.
Zwijndrecht, 1887

Watercolor over a preliminary drawing in graphite pencil on white wove paper; 225 x 286 mm

INSCRIPTIONS: Signed with brush and dark brown ink on recto at lower left, *CN Storm van 's Grave-sande;* titled and dated with brush and watercolor on verso at lower center, *"Zwijndrecht" 1887;* with brush and watercolor on verso at lower left, *№ 10*

ANNOTATIONS: With red chalk on verso at upper left, *No 10.* [crossed out with pencil]; with pencil on verso at upper left, *No 4;* with pencil on verso at lower right, *ax* [indecipherable]

WATERMARK: J. Wha[tman]

CONDITION: Slight staining at top edge; crease lower left corner

PROVENANCE: Charles L. Freer, Detroit

EXHIBITION: New York 1889, no. 10

REFERENCE: Detroit 1967, p. 49

Gift of Charles L. Freer (1905.5)

Zwijndrecht is in Belgium in the vicinity of Antwerp.

55.
The Herring Fleet, Katwijk

Charcoal on buff wove paper; 479 x 680 mm

INSCRIPTIONS: Signed with charcoal on recto at lower left, *CN Storm van 's Gravesande*; with black chalk on verso in lower left corner, *2*; with black chalk on verso at lower left, *Katwijk*

ANNOTATIONS: With pencil on verso at center left, *4224* [inverted]; with pencil on verso at lower right, *FCX*ox

CONDITION: Yellowed; irregular staining in vertical line at center

PROVENANCE: Charles L. Freer, Detroit

REFERENCE: Detroit 1967, p. 49

Gift of Charles L. Freer (1905.391)

Storm van 's Gravesande used the drawing for a similar etching, *Landing of the Herring Fleet, Katwyk* (copyrighted 1888; New York 1889, no. 264), also in Detroit (1905.282–283). There are minor differences at the left in the print, where fewer people are gathered along the shore, and the building in the distance was omitted. Katwijk is near Leiden on the coast.

Flemish Drawings

David Joris

1501 Ghent–Basel 1556

56.
Christ Giving the Keys to Saint Peter,
ca. 1524–29

Pen and brown ink and gray wash on discolored laid
paper; 237 x 191 mm

INSCRIPTION: With pen and brown ink on verso at
upper edge and center [indecipherable]

ANNOTATIONS: With pen and black ink on verso at
upper center, *382*; with pencil on verso at center,
[indecipherable]

WATERMARK: Pot (Briquet, pp. 34–36)

CONDITION: Paper fragile; surface abraded with loss
to image; surface grime and staining, especially at
right; repaired upper right corner

PROVENANCE: Jacob Moelaart, Dordrecht; N. Beets,
Amsterdam

REFERENCES: Houbraken 1718–21, pp. 10–11; Koegler
1930, pp. 170–171, 198–200, pl. 18; Bock and Rosen-
berg 1930, p. 38 (under no. 11827, companion piece to
drawing in Beets collection); Valentiner 1934,
pp. 5–7, ill. p. 57

Founders Society Purchase, William H. Murphy
Fund (1934.97)

Christ Giving the Keys to Saint Peter (Matthew
16:19) is one of the four drawings mentioned by
Arnold Houbraken as in the collection of Jacob
Moelaart in Dordrecht in the early eighteenth cen-
tury. Its companion sheet, the *Story of the Cen-
turion,* is in Berlin (inv. 11827; Bock and Rosenberg
1930, p. 38), while the other two drawings remain to
be identified.

As Houbraken correctly pointed out, the execu-
tion of the drawing is close in style to Lucas van
Leyden (1494?–1533), but the emphasis on the con-
tours, as well as the light modeling with wash, relate
the study to drawings by Jan Swart (ca. 1500–after
1553) and Dirk Vellert (active 1511–1544). The com-
position may have been part of a series more exten-
sive than the four sheets mentioned by Houbraken.
Although Joris was a well-known stained-glass
painter, no window after *Christ Giving the Keys* is
known.

Unknown Flemish Artist

Active mid-sixteenth century

57.
Ruins of a Church, ca. 1550

Pen and black ink on discolored laid paper; 88 x 120 mm

ANNOTATION: With pencil on verso at lower right on a piece of paper pasted over original sheet to repair a tear, *Jan van Scorel*

CONDITION: Foxing; surface grime; stains upper and lower right with red accretions; repaired loss lower left; right edge trimmed

PROVENANCE: Unidentified collectors (blue collector's marks on verso in lower right and left corners); Schaeffer Galleries, Inc., New York

Founders Society Purchase, Elizabeth P. Kirby Fund (1947.74)

Hans Vereycke, to whom this drawing was previously attributed, is practically unknown as an artist. According to Carel van Mander, he was a painter who lived in Bruges and bore the nickname *"kleen Hansken"* (small Hans). He was said to have been a good landscape artist, a fairly good portrait painter, and to have worked after nature (Van Mander 1604, p. 90). Vereycke is at times identified with Jan van Eeckele from Bruges, who was accepted into the guild of that city in 1534 and died in 1561.

The single drawing in the Louvre that once bore an old annotation *"Vereycken"* on the mount differs too much in execution from the Detroit drawing, particularly in the rendering of the trees, to be given to the same hand that executed *Ruins of a Church* (for a discussion of Vereycke, see Paris 1968, cat. nos. 155–156, pl. 75, and Franz 1969, pp. 68–70, figs. 46–49). The pen drawings that Benesch attributed to Vereycke are dissimilar in the execution of the trees and foliage as well and appear to be by yet another hand (Benesch 1943, pp. 269–282, especially figs. 5, 8, 10–15). The *Woody Landscape* in Munich (signed *Cleen H. fecit* and dated *1598*) must be by an altogether different draftsman, since Vereycke more

than likely died in 1561 (for further discussion of the problem, see Munich 1973, cat. no. 148, pl. 62; the attribution of this group of drawings is also discussed in Zwollo 1965, pp. 43–65).

Julius S. Held should be credited with raising the question of whether the drawing in Detroit could be by one of the hands responsible for the copies at the beginning of a sketchbook attributed to followers of Joachim Patinir (d. ca. 1524) in Berlin (inv. 79C 2; see Held 1933, pp. 273–288, and Mielke in Berlin 1975, cat. no. 180, figs. 20–22, for the most recent summary of the problems relating to this sketchbook). A certain resemblance indeed exists to a few of the landscape drawings included in the beginning of the sketchbook, most notably to the recto of folio 74 dated 1540 (fig. 9), which renders a ruined building, although it is drawn somewhat more coarsely than the example in Detroit. Related as well is the folio with a church in a hilly landscape against mountains in the distance (fol. 53v; fig. 10), a motif also found twice in the contemporary *Errera Sketchbook* in Brussels, folios 23 and 113 (see Franz 1969, figs.71–73).

The Detroit drawing seems to reflect a related interest in buildings in a landscape setting. Certain unclear passages in the rendering of the steps in the foreground and the archway in the middle distance at the left seem to indicate that it is a copy, although no prototype is known. The sheet in Detroit is here given to an unknown Flemish artist working in the same tradition as the landscape draftsman responsible for the copies in the beginning of the Berlin sketchbook. The drawing probably dates from the mid-sixteenth century.

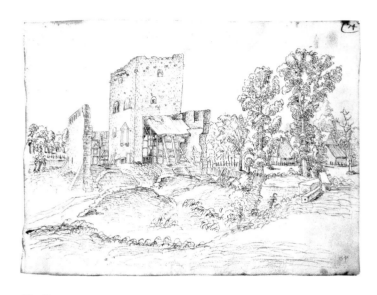

Fig. 9.
Landscape with Ruined Church, 1540, fol. 74r of *Netherlandish Sketchbook*, Antwerp, ca. 1530-43. Pen and dark brown ink over traces of black chalk, 190 x 254 mm. Staatliche Museen, Preussischer Kulturbesitz, Kupferstichkabinett, Berlin-Dahlem (inv. 79C 2). Photo: Jörg P. Anders, Berlin.

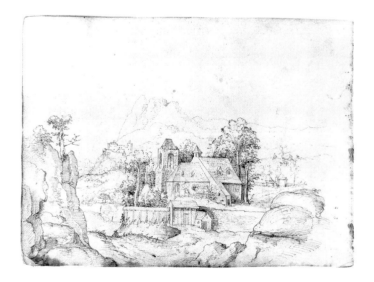

Fig. 10.
Landscape with a Church, ca. 1530-40, fol. 53v of *Netherlandish Sketchbook*, Antwerp, ca. 1530-43. Pen and black ink, 190 x 254 mm. Staatliche Museen, Preussischer Kulturbesitz, Kupferstichkabinett, Berlin-Dahlem (inv. 79C 2). Photo: Jörg P. Anders, Berlin.

Marten de Vos

1532 Antwerp 1603

58.
Christ Healing the Palsied Man, 1586

Plate XVI

Pen and brown ink and brown wash, heightened with white, on light brown laid paper; 189 x 148 mm

INSCRIPTION: Signed and dated with pen and brown ink on recto at lower left, *M D VOS. F 1586*

ANNOTATIONS: With pencil on recto of mount in lower left corner, *No 1224* [crossed out] *321*; with pen and brown ink on recto of mount at lower left, *Martin de Vos*; with pencil on recto of mount at lower right, *p* [indecipherable]

CONDITION: Several faint indentations are visible that roughly correspond to the principal lines of the drawing, indicating that the drawing may have been traced; solidly mounted to thin cardboard; some white lead discoloration; abrasion left side; loss lower left corner; tear bottom center

PROVENANCE: Unidentified collector (brown collector's mark on verso of mount at upper left); sale, Sotheby's, London, March 1889; James E. Scripps, Detroit, 1889

Gift of Mrs. James E. Scripps (1909.1 S-Dr. 321)

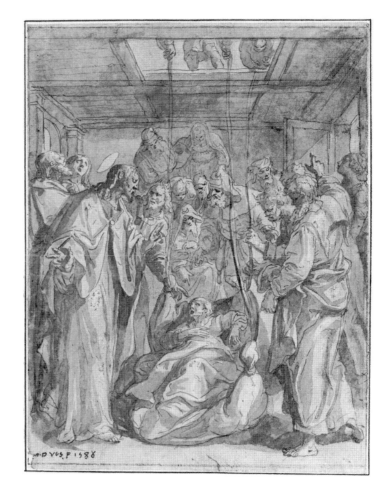

The drawing represents the story told in Mark 2:2–5. When Christ preached in a house in Capernaum, it became so crowded that there was no more room for the man with palsy. His friends uncovered the roof and lowered the man on his bed down into the house. Christ was so moved by the faith of the man's friends that he healed the palsied man.

The study may have been part of a series of New Testament scenes. Several such sheets by De Vos are known that also date from the 1580s (Paris 1968, nos. 400–427). Although the sheet was traced for transfer, no print after the drawing is known, nor is it mentioned in Reinsch's study of De Vos's drawings (Reinsch 1967). See also cat. no. A15.

David Teniers the Younger

1610 Antwerp – Brussels 1694

59.
Peasant Raising a Glass of Wine, ca. 1644

Graphite pencil on discolored laid paper;
202 x 153 mm

ANNOTATIONS: With pencil on verso at upper center, *D. Teniers / 4 / 1610–90*; with pencil on verso at upper left, *Teniers*; with pencil on verso in center, *119* [in circle and crossed out]; with pencil on verso at lower left, *968* [in circle]; with pencil on verso at lower left, *D. Teniers (Original (Winter) ex four Seasons / 1610-90 in Nat. Gallery, London)* with the word *Autumn* over the word *Winter*; with pencil on verso in lower left corner, *215*; with pencil on verso at lower right, *2532d /* [indecipherable]; with pen and brown ink on verso at lower right, *506.*; with pencil at lower right, [indecipherable]

CONDITION: Surface grime and accretions; skinned at top, left, and lower edges; stains left edge; cockling; repaired tear at bottom center

PROVENANCE: L. Deglatigny, Rouen (red collector's mark [L. Suppl. 1768a] on recto at lower left); Paul Wescher, Berlin

REFERENCES: Weigel 1861, pl. XXXIII b; *BDIA* 1939: 11

Founders Society Purchase, William H. Murphy Fund (1938.20)

This is a preliminary study for Teniers's signed painting of *Autumn*, on copper and approximately the same size, in the National Gallery, London (fig. 11; London 1970, pp. 259-261, no. 859; ill. in London 1973, p. 708, and a copy, p. 712, no. 953). The peasant is raising a glass of wine while standing in front of a shed where grapes are being processed. This small painting is part of a series of the Four Seasons, all preserved in the National Gallery and dated by Martin (London 1970) and others to ca. 1644. The drawing most likely originated at approximately the same time.

Fig. 11.
David Teniers the Younger. *Autumn*, ca. 1644. Oil on copper, 221 x 164 mm. National Gallery, London (inv. 859).
Photo: National Gallery.

Unknown Flemish Artist

Active late sixteenth century

60.
Village on a River with a Castle on a Hill,
ca. 1600

Pen and brown ink and red chalk on parchment;
142 x 224 mm

ANNOTATIONS: With pen and brown ink on verso at
upper edge, *.n Stifania io Egregio pictore Italo / de-
picta cum absito monte Sancti Georgy*; with pencil
on verso at upper left, *10*; with pencil on verso at
lower center, *Roelandt Savery 1576–1629*

CONDITION: Cockling

PROVENANCE: B. Jolles, Dresden and Vienna (blue
collector's mark [L. Suppl. 381a] on recto in lower
right corner); E. Speelman, London

REFERENCE: *BDIA* 1935: 57 (as Roelant Savery)

Founders Society Purchase, William H. Murphy
Fund (1934.102)

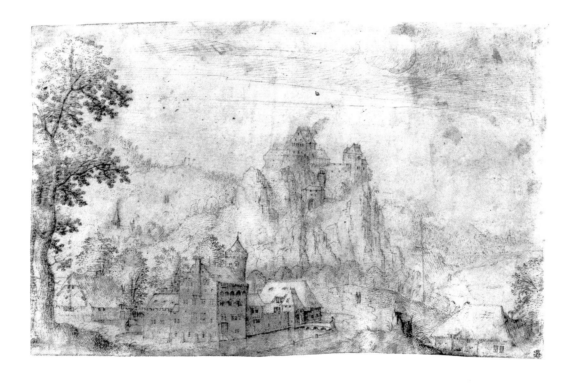

The attribution to Roelant Savery (1576–1639) was rejected by Joaneath Spicer (letter to the author, February 7, 1977), who did not include it in her 1979 catalogue of the artist's drawings. She referred to a related drawing of a *Village Scene,* with a questionable attribution to Jan Brueghel the Elder, in the Herzog Anton Ulrich-Museum, Brunswick (inv. no. Z 483). Spicer suggested further that, in composition, the Detroit drawing reflects prints of the 1580s by Pieter van der Borcht (ca. 1535–1608). The study, therefore, probably is by a Flemish artist working in the last quarter of the sixteenth century (see Mielke 1979, pp. 63–71, for the most recent discussion of Flemish landscapes of this period).

Unknown Flemish Artist

Active seventeenth century

61.

Descent from the Cross

Pen and brown ink and gray wash accentuated with brush and black ink on discolored laid paper; 301 x 192 mm

ANNOTATIONS: With pen and brown ink on verso of mount at lower center, *No 47*; with pencil on verso of mount in lower left corner, *0.77*

CONDITION: Solidly mounted; horizontal crease across center

PROVENANCE: E. Parsons & Sons, London, cat. 46, no. 263 (as Van Dyck)

REFERENCE: Scheyer 1936, no. 75 (as Jordaens)

Founders Society Purchase, Octavia W. Bates Fund (1934.118)

The earlier attributions to Anthony van Dyck and Jacob Jordaens are untenable. Rather, the drawing seems to be a study by an unidentified seventeenth-century Flemish artist who was familiar with Rubens's *Descent from the Cross* of ca. 1615–17 in the Musée des Beaux-Arts, Lille (inv. KdK 89), and Gaspar de Crayer's (1584–1669) *Deposition* of 1621–23 in the church of Saint Martin in Millau (Foucart and Lacambre 1978, p. 6, fig. 1; Vlieghe 1972a, no. A10, as lost). A painting corresponding to this drawing remains to be identified.

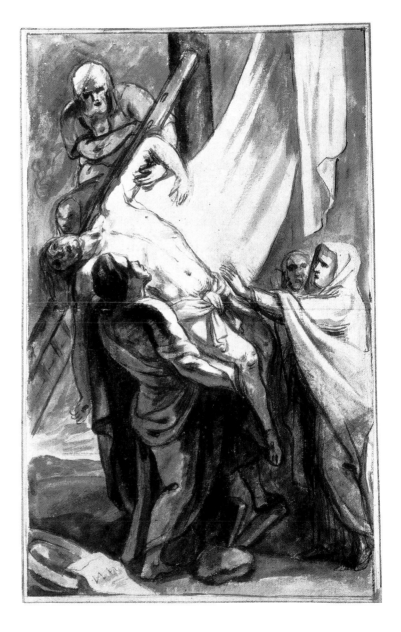

Copy after
David Vinckboons

62.
Landscape with a Stag Hunt, early seventeenth century

Pen and brush and brown ink and blue and brown wash over traces of graphite on discolored paper; 209 x 315 mm

ANNOTATIONS: With pen and brown ink on recto at lower right, *788.*; with pencil on verso of mount at upper left, [indecipherable]; with pencil on verso of mount at lower left, *A5646*; with pencil on verso of mount at lower right, *R. Savery*

CONDITION: Solidly mounted to thin cardboard

PROVENANCE: Flury-Hérard, Paris (black collector's mark [L. 1015] on recto in lower right corner);

C. Otto, Leipzig (brown collector's mark [L. Suppl. 611c] on verso of mount at lower left); D. Giese, London

REFERENCES: *BDIA* 1938: 40; Thieme and Becker 1907–50, 34: p. 388; Bergsträsser 1979, under no. 133 (copy); Wegner and Pée 1980, p. 114, under no. Z 3 (as copy after drawing in Darmstadt)

Founders Society Purchase, William C. Yawkey Fund (1937.55)

This sketchily drawn landscape with a stag hunt is copied after a slightly smaller version in Darmstadt which, according to Gisela Bergsträsser, is by David Vinckboons (1576–ca. 1632) and dates from ca. 1600–16 (fig. 12; inv. no. AE 542). Bergsträsser noted some differences from Vinckboons's accepted drawings, especially in the rendering of the leaves, and thus based her attribution primarily on the drawing's close association with an engraving of the same subject by Jan van Londerseel (ca. 1570/75–1624/25) (fig. 13; Hollstein 1949–, 11: 102, no. 86) that credits Vinckboons with the invention. Wolfgang Wegner, in his critical study of Vinckboons's drawings, published posthumously by Herbert Pée in 1979, was less certain about the authorship of the Darmstadt drawing and included it among the Vinckboons

drawings with some reservation (no. Z 3). In his opinion, the similarity with the above-mentioned engraving is less obvious. Instead, he favored another print by Londerseel, again after a lost Vinckboons drawing, namely, the *Landscape with the Feast in the Forest* (fig. 14; Hollstein 1949–, 11: 102, no. 82). In this latter example the trees in the foreground and the water and castle in the middle distance are indeed similar to the drawing in Darmstadt (and its copy in Detroit), but the boats and hunters aiming at the stag are missing. The Darmstadt and Detroit drawings, therefore, give a representation that combines elements from the two Londerseel engravings after lost drawings by Vinckboons. If Vinckboons were indeed the author of the Darmstadt drawing, in the opinion of Wegner it would represent one of his earliest studies, drawn ca. 1598–99.

Wegner also considers the Detroit drawing as a copy after the sheet in Darmstadt. Earlier, he had intended to publish it as a work by Hessel Gerritsz (1581–1632), a Dutch draftsman who was an early pupil of Vinckboons (letter to Ellen Sharp, December 15, 1974; Curatorial Files). As Julius S. Held pointed out (verbally), the study more likely belongs to a group of so-called pseudo-Vinckboons drawings that are often enriched with watercolor.

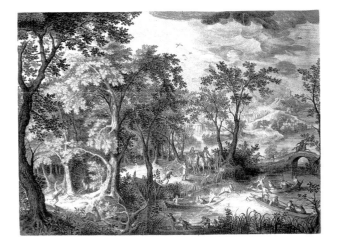

Fig. 12.
David Vinckboons (attributed to). *Wooded Landscape with Castle and Deer Hunt*, ca. 1598-99(?). Pen and brown ink and blue wash, 200 x 295 mm. Hessisches Landesmuseum, Kupferstichkabinett, Darmstadt (inv. AE 542). Photo: Hessisches Landesmuseum.

Fig. 13.
Jan van Londerseel, after David Vinckboons. *Landscape with a Stag Hunt* (see Hollstein 1949–, no. 86). Engraving, 345 x 480 mm. Rijksmuseum, Prentenkabinet, Amsterdam. Photo: Rijksmuseum.

Fig. 14.
Jan van Londerseel, after David Vinckboons. *Landscape with the Feast in the Forest* (see Hollstein 1949–, no. 82). Engraving, 295 x 422 mm. Staatliche Graphische Sammlung, Munich (inv. 35868). Photo: Staatliche Graphische Sammlung.

Appendix

Circle of Nicolaes Berchem

A1.

Italianate Landscape with Figures, ca. 1650–70

Pen and gray and black ink and gray wash over traces of graphite pencil on discolored laid paper; 258 x 372 mm

INSCRIPTION: Signed with pen and ink on recto at lower left and later erased

ANNOTATION: With pencil on verso at upper left, [indecipherable]

CONDITION: Erasure lower left; repaired loss center lower edge; mat burn, foxing, and abrasion at edges; creasing upper left corner; cockling

PROVENANCE: Schaeffer Galleries, Inc., New York; John S. Newberry, New York, 1948

EXHIBITIONS: Detroit 1949, no. 3 (as Berchem); Detroit 1965 (as Berchem)

REFERENCES: Detroit 1949, no. 3, ill. (as Berchem); *BDIA* 1959/60: 43 (as Berchem); Detroit 1965, p. 13, ill. (as Berchem)

Gift of John S. Newberry in memory of Dr. Wilhelm R. Valentiner (1959.13)

The drawing's former attribution to Nicolaes Berchem (1620–1683), a Dutch artist specializing in Italianate landscapes, must be modified. While the subject matter of the drawing is reminiscent of Berchem, it is in a direct comparison with a signed Berchem drawing such as the *Crossing of the Ford* in the Lugt collection, Paris (inv. 409; New York and Paris 1977–78, no. 7, pl. 117) that the difference becomes noticeable. There the pen is freer, the lines are more nervously drawn, and the wash is more differentiated. The Detroit drawing, in contrast, is drawn in a rather pedantic manner that suggests a follower or even copyist after Berchem.

The signature of the artist responsible for this drawing, as well as the date, was once inscribed at the lower left on the protruding wall; they were subsequently erased and are now completely illegible.

Copy after Jan de Bisschop

A2.

Flying Angel, seventeenth century

Pen and sienna and brown ink on cream laid paper; irregular, 165 x 207 mm

ANNOTATIONS: With pen and brown ink on recto at lower center, *JB* [partially cut off] *14* [indecipherable]; with pencil on verso at upper left, *S 89*

CONDITION: Uneven discoloration; irregularly trimmed on all four sides; creasing and fold marks

PROVENANCE: A. Koenig; C. J. Meyer, Carlsbad; James E. Scripps, Detroit, September 1887

REFERENCE: Van Gelder and Jost 1985

Gift of Mrs. James E. Scripps (1909.1 S-Dr. 61)

This drawing, which was acquired as a work of Cavalier d'Arpino (1568–1640), is a copy after the etching by Jan de Bisschop (ca. 1628–1671) in his *Paradigmata graphices variorum artificum*, The Hague, 1671, pl. 9. The plate is inscribed at lower left, *Jos. Arp. inv.d.*. De Bisschop's etching is made after the drawing by d'Arpino, which may once have been in the collection of Lambert ten Kate, an eighteenth-century Dutch collector (sale, Amsterdam, 1732, Port. A, no. 8; the black chalk drawing, slightly larger than the print, was bought for thirty guilders by A. Rutgers and later by Cornelis Ploos van Amstel [1726–1798], who paid

eight guilders for it. This information was kindly pointed out by J. G. van Gelder, letter to the author, August 21, 1979; see also Van Gelder 1970, p. 167, fig. 13, and p. 173). Two additional copies after the same print are known. One of them, a pen-and-ink drawing, is in the Kupferstichkabinett, Berlin (inv. 18 323), as pointed out by Herwarth Röttgen (letter to Ann Sutherland Harris, May 2, 1979; Curatorial Files); the other one, in red chalk, is in the De Grez collection, Brussels (cat. 1913, no. 301), as J. G. Van Gelder kindly informed the author (letter, August 21, 1979).

Copy after Jan Both (?)

A3.
River Landscape with Figures, seventeenth century

Black chalk on buff laid paper; 157 x 208 mm

ANNOTATIONS: With black chalk on recto at lower left, *J. Both*; with pencil on verso at lower center, *J. Both*

CONDITION: Tipped down to heavy paper; scattered stains and foxing; surface grime

PROVENANCE: Unidentified collector (purple collector's mark on recto at lower left); W. Schatzki, New York

REFERENCE: *BDIA* 1962: 32 (as unknown Dutch, mid-seventeenth-century)

Founders Society Purchase, Elizabeth P. Kirby Fund (1961.200)

The attribution to Jan Both (1610–1652) suggested by annotations on the drawing is erroneous. The drawing may possibly record a composition of Both's that remains to be identified.

Copy after Allaert van Everdingen

A4.
Landscape with a Millstone near a Cask,
second half of the eighteenth century

Pen and black ink on white laid paper; 135 x 114 mm

ANNOTATION: With pen and black ink on recto at lower right, *AW*

WATERMARK: Pro Patria

CONDITION: Foxing; some cockling

PROVENANCE: C. J. Meyer, Carlsbad; James E. Scripps, Detroit, 1887

Gift of Mrs. James E. Scripps (1909.1 S-Dr. 324)

This drawing is a copy after Allaert van Everdingen's (1621–1675) etching *The Mill-stone near the Cask* (Hollstein 1949–, 6: no. 9), which is identical in size. The print belonged to the series of one hundred landscapes by Van Everdingen that P. van den Boom published in Amsterdam in 1696 as *Recueil de cent paysages inventées et gravées à l'eau forte par A. van Everdingen* with a title page by C. Hodges (ibid., p. 153). The copyist most likely altered Van Everdingen's monogram *AVE* at bottom right into *AW*, which must have prompted the earlier erroneous attribution of the drawing to Anthonie Waterloo (ca. 1610–1690). No print by Waterloo with this subject is known (see Leach and Morse 1978, 9–128, nos. 1–137 for illustrations).

Based on an analysis of the paper, which was manufactured sometime after 1750, the drawing must date from the latter part of the eighteenth century.

Copy after Hendrik Goltzius

A5.
Saint Andrew, seventeenth century

Pen and brown ink and brown wash over a preliminary drawing in black chalk on white laid paper; 301 x 224 mm

ANNOTATIONS: With pencil on verso of mount at center, *7*; with pencil on verso of mount at lower right, *A. 22797*; with pencil on verso of mount at lower right, *II 11*

CONDITION: Solidly mounted; considerable losses (apparently insect damage) toned in with color

PROVENANCE: Rockman Prints, New York; Mr. and Mrs. Bernard F. Walker, Bloomfield Hills, Michigan, 1960

REFERENCE: *BDIA* 1969: 17 (as *Saint John on Patmos*)

Gift of Mr. and Mrs. Bernard F. Walker (1968.29)

This is a seventeenth-century copy after an engraving by Hendrik Goltzius (1558–1617) of *Saint Andrew* from the series of *Christ and the Apostles* (Strauss 1977, 2: 469, no. 268), as Julius S. Held kindly pointed out (verbally).

Copy after Jan van Goyen

A6.

Fishermen near the Shore, second half of the eighteenth century

Black chalk and gray wash on buff laid paper with brown fibrous inclusions; 120 x 200 mm

ANNOTATIONS: With pencil on verso at center, *Simon de Flieger!* [sic]; with pencil on verso at center right, *3*; with pencil on verso at lower right, *Van Goyen* [indecipherable]

CONDITION: Good

PROVENANCE: E. Speelman, London

REFERENCES: *BDIA* 1935: 57 (as Van Goyen); Scheyer 1936, no. 78, ill. (as Van Goyen)

Founders Society Purchase, William H. Murphy Fund (1934.106)

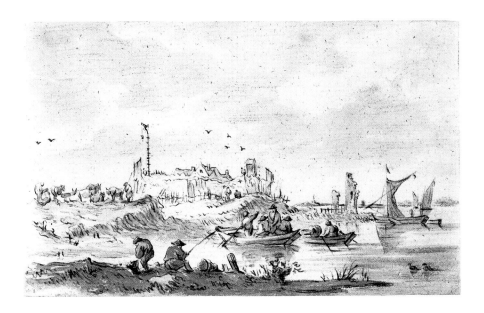

The drawing, attributed to the Haarlem landscape artist Cornelis Symonsz. van der Schalcke (1611–1671), copies a signed study by Van Goyen (see cat. nos. 8 and 9) of similar dimensions and dated 1653 now in Berlin (Bock and Rosenberg 1930, p. 142, no. 2765, pl. 103; Beck 1972–73, 1: 156, no. 458, ill.). The only slight deviations consist of the addition of a fishing rod for the man seated in the center foreground and of the two ducks swimming at the lower right. The same walled fort overlooking the river is also known from a signed painting by Van Goyen in the Rheinisches Landesmuseum, Bonn, dated 1651 (Beck 1972–73, 2: p. 124, no. 254).

The attribution to Van der Schalcke has yet to be confirmed. His oeuvre is very small (see Van Regteren Altena 1926) and only two signed drawings are known: one in the Kunsthalle, Hamburg (inv. 22 493; Bernt 1957–58, 2: no. 536, ill.), the other in the Lugt collection, Paris (inv. 1691; Paris 1968–69, no. 142, pl. 55), both dated 1660. Judging from these two examples, Van der Schalcke's use of chalk was much more fluid and his line more undulating than in the Detroit drawing, an element completely absent in this study.

The attribution to Simon de Vlieger (1601–1653), as suggested in an annotation on the verso, is rejected by Jan Kelch (letter to the author, July 24, 1979).

Based on the paper, which reflects a change in mold making that happened around 1750, the drawing dates from the latter half of the eighteenth century (kindly pointed out by Nancy Harris).

Imitator of Adriaen and Isaac van Ostade

A7.

Group of Peasants and a Violinist in Front of a Tavern, seventeenth/eighteenth century

Pen and brown ink, gray wash, and black chalk, heightened with white, on blue laid paper; 223 x 179 mm

ANNOTATIONS: With black chalk on verso at lower left, *112/L*; with black chalk on verso at lower center, *A. v. Ostade 410* [?], and over it with pencil, *80*

WATERMARK: S.G.

CONDITION: Paper fragile; abrasion and small losses along left and lower edges

PROVENANCE: W. P. Knowles, Rotterdam and Wiesbaden (blue collector's mark [L. 2643] on verso at lower left, *WPK*), sale, Muller, Amsterdam, June 25, 1895, no. 477 (as A. van Ostade); Hauser, Karlsruhe, sale, Leipzig, Boerner, May 4, 1905, no. 460, ill. (as A. van Ostade); DeGruyter; Berg, Portland, Oregon; C. B. Duhrkoop

REFERENCES: Lesley 1939, p. 4, ill. (as Isaac van Ostade); Schnackenburg 1981, cat. F.70 (imitation)

Founders Society Purchase, William H. Murphy Fund (1938.16)

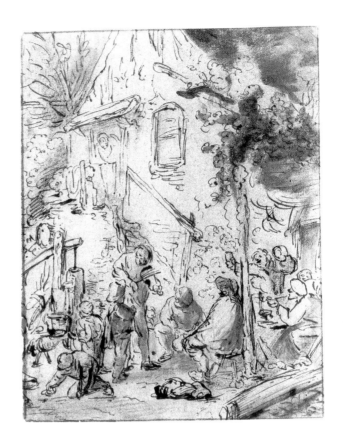

According to Bernard Schnackenburg (letter to the author, August 2, 1977), this drawing is by an imitator of the Van Ostades (see cat. nos. 16 and A8), an opinion also supported by Julius S. Held (verbally).

Copy after Adriaen van Ostade

A8.

Woman Frying Pancakes, eighteenth century

Pen and brown ink and watercolor on buff laid paper; 195 x 163 mm

ANNOTATIONS: With pencil on verso at upper edge, *Frying Pancakes / A van Ostade / Purchased from the Esdale [sic] collection*; with pen and brown ink on verso at lower center, *AVan Ostade* [by Esdaile]

WATERMARK: Strasbourg lily (cf. Churchill 401)

CONDITION: Repaired upper right corner; possible scattered retouching

PROVENANCE: W. Esdaile, London (collector's mark [L. 2617] with pen and ink on verso at lower left, *1831 WE 12xx*); W. H. Fanning; James E. Scripps, Detroit, 1887; Mrs. William E. Scripps, Detroit

REFERENCES: Paris 1981, no. 13 (as old copy); Schnackenburg 1981, cat. 232 (copy)

Gift of Mrs. William E. Scripps (1956.290)

The Detroit drawing is probably an eighteenth-century copy after Adriaen van Ostade's (see cat. nos. 16 and A7) drawing in the Lugt collection, Paris, signed at lower right and dated 1673. The latter was also in the Esdaile collection and bears Esdaile's date of acquisition, 1835 (New York and Paris 1977–78, no. 74, pl. 103). Judging from the date of *1831* inscribed by Esdaile on the verso of the Detroit drawing, we may assume that he bought this drawing first and subsequently acquired the original by Van Ostade now in Paris.

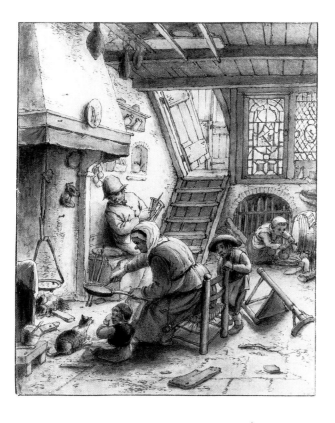

Copy after Cornelis Saftleven (?)

A9.
Interior Seen through an Open Door, seventeenth century

Black chalk, brush and gray ink and gray wash on white laid paper; 182 x 130 mm

ANNOTATION: With pencil on verso at lower center, *g.a.*

CONDITION: Creasing along bottom edge probably occurred at time sheet was manufactured

PROVENANCE: E. Speelman, London

REFERENCES: *BDIA* 1935: 57 (as Cornelis Saftleven); Scheyer 1936, no. 76 (as Cornelis Saftleven)

Founders Society Purchase, William H. Murphy Fund (1934.100)

A number of similar drawings of interiors by Cornelis Saftleven (1607–1681), also executed in black chalk and gray wash, are known (see Schulz 1978, nos. 221–237). Particularly close are two studies of *Stairs Leading to a Door* in the Musée des Beaux-Arts, Besançon (inv. D-294/295) and another example in the Lugt collection, Paris (no. XLIII). The attribution of the Detroit drawing to Cornelis Saftleven, however, is doubted by Wolfgang Schulz, who considers it more likely to be a copy after an unknown sheet by Saftleven (letter to the author, June 28, 1977). The Detroit drawing is not mentioned in Schulz's 1978 catalogue of Saftleven's oeuvre.

Unknown Dutch Artist

A10.
The Quack Doctor, eighteenth/nineteenth century

Pen and dark brown ink and brown wash over a preliminary drawing in red chalk on discolored laid paper; 244 x 190 mm

CONDITION: Solidly mounted; some loss of image through abrasion, especially lower left and right corners; crease and fold across top

PROVENANCE: Frederick Keppel, New York; James E. Scripps, Detroit, 1899; Mrs. William E. Scripps, Detroit

REFERENCE: *BDIA* 1956/57: 51 (as Jan Steen)

Gift of Mrs. William E. Scripps (1956.289)

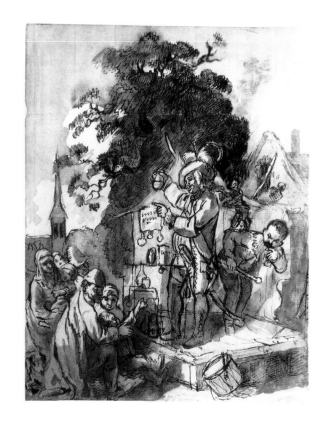

The earlier attribution of the drawing to Jan Steen (1626–1679) is untenable. Judging from the costume worn by the quack, the drawing more likely is of the eighteenth or even the nineteenth century.

Unknown Dutch Artist (?)

A11.
Landscape with Cottages and Figures, second half of the eighteenth century

Pen and brush and dark brown ink and dark brown wash, heightened with pinkish white, over traces of black chalk on blue wove paper; 356 x 486 mm

ANNOTATIONS: With pencil on verso at upper left, *57*; with pencil on verso at lower right, *B*; with pencil on verso in lower right corner, *7.711* [in circle]

CONDITION: Accretion near center of sheet; some creasing and abrasion; vertical fold near center

PROVENANCE: E. Parsons & Sons, London

REFERENCE: *BDIA* 1935: 57 (as Herman Saftleven)

Founders Society Purchase, Octavia W. Bates Fund (1934.101)

The former attribution to Herman Saftleven (1609–1685) cannot be sustained. The wove molds necessary to create this type of paper were not used in Europe until after 1757 (kindly pointed out by Nancy Harris). The study, therefore, most likely originated in the latter part of the eighteenth century and may be by an Italianate Northern artist.

Imitator of Johan Barthold Jongkind

A12.
Boats on a Canal and Windmills near Dordrecht, ca. 1920 (?)

Watercolor over traces of graphite pencil on discolored laid paper; 281 x 452 mm

INSCRIPTIONS: Inscribed with pen and brown ink on recto at lower right, *Jongkind*; with pencil on recto at lower center, *Dordrecht 1864*

WATERMARK: Crest

CONDITION: Solidly mounted to gray board; mat burn; foxing

PROVENANCE: Mrs. George Kamperman, Detroit

REFERENCES: *BDIA* 1965: 16 (as Jongkind); Detroit 1967, p. 63 (as Jongkind)

Gift of Mrs. George Kamperman in memory of her husband, Dr. George Kamperman (1964.219)

This watercolor, although supposedly signed by Jongkind (1819–1891) at the lower right and inscribed *Dordrecht 1864* at lower center, is not convincing as a work by the artist. The motifs are Jongkind's but the execution and the color scheme are completely foreign to his securely attributed watercolors (see cat. nos. 35–37). The hull of the sailboat in the left foreground is drawn so sketchily that it becomes difficult to decipher. Furthermore, it lacks depth and seems to merge into the windmill in the middle distance to the extent that both appear to belong to the same spatial plane. This lack of definition of the boat, as well as of the mills and houses in the distance, are uncharacteristic of Jongkind. The "signature" is written in a way that relates closely to the estate stamp applied to the rectos of all the

drawings and prints found in his estate in 1891 (L. 1401). It is identical with the one applied to the following drawing, *Quai on the Seine, Paris*, which is by the same twentieth-century forger who, according to Dr. Victorine Hefting (verbally, 1977), was working in Brussels in the 1920s.

Dr. Hefting also pointed out that Jongkind was not in Dordrecht in 1864 and that he never would have written out the city's name in full, but would have preferred the colloquial abbreviation *Dort*, commonly used by the Dutch. According to her, the number four in the date *1864* is not in Jongkind's handwriting either. These various facts support the elimination of the drawing from Jongkind's oeuvre.

Imitator of Johan Barthold Jongkind

A13.

Quai on the Seine, Paris, ca. 1920 (?)

Watercolor and black chalk on discolored laid paper;
387 x 535 mm

INSCRIPTIONS: Inscribed with pen and brown ink on recto
at lower right, *Jongkind*; with pencil on recto at lower cen-
ter, *6 Juin*

WATERMARKS: Shield enclosing a staff topped with a
winged hat and entwined by two serpents; C.F. at the
bottom [incomplete]

CONDITION: Foxing; mat burn; small edge tears

PROVENANCE: Albert Kahn, Detroit

EXHIBITION: Northampton and Williamstown 1976–77,
no. 21

REFERENCES: Heil 1931, p. 40, ill. (as Jongkind); Detroit
1967, p. 63 (as Jongkind); Northampton and Williamstown
1976–77, no. 21, ill. (as Jongkind, ca. 1860, but with refer-
ence to Hefting's doubts)

Gift of Albert Kahn (1930.289)

There are several features of this watercolor that cast doubt
on Jongkind's authorship. First, the underdrawing in black
chalk is applied rather uniformly in horizontals and diago-
nals without the free-flowing stroke known in other Jong-
kind watercolors (see cat. nos. 35–37). The washes, too, are
applied in the same, rather methodical, manner. The ren-
dering of the figures differs from Jongkind's as well, because
they end in too pointed a silhouette and do not stand firmly
on the ground. The "signature," finally, betrays the same
forger responsible for the previous drawing.

Copy after Tobias Verhaecht

A14.

Fishermen in a Mountainous Landscape,
seventeenth century

Pen and brown ink, brown wash, and traces of graphite on
buff laid paper; 257 x 328 mm

WATERMARK: Four-legged animal (cf. Briquet 5948)

CONDITION: Severe staining, some ink lines blurred; re-
paired lower left corner; some areas touched up with white;
small skins, tears, and losses; surface grime; accretions and
abrasions

PROVENANCE: V. W. Newman, New York (blind stamp
[L. 2540] on recto in lower right corner); P. de Boer,
Amsterdam

REFERENCE: *BDIA* 1938: 40 (as Tobias Verhaecht)

Gift of P. de Boer (1937.25)

The same mountainous landscape is also known from a
drawing of the same size by Tobias Verhaecht (1561–1637)
formerly in the collection of E. Perman, Stockholm (Bernt
1957–58, 2: no. 622, ill.), now in a private collection in
Belgium (Brussels 1983, no. 23, ill.), and from a slightly
different version in the Plantin-Moretus Museum, Ant-
werp (inv. A.XII.9; Antwerp 1938, pp. 48–49, pl. xxiv). Fur-
thermore, there are at least four known painted versions

executed by Verhaecht and his circle of a closely related
rocky landscape, although with varying staffage. The best
one, *Rocky Landscape with Abraham Leaving Lot*, signed
and dated *1609*, is in the Herzog Anton Ulrich-Museum in
Brunswick (Brunswick 1976, p. 59, pl. 21). Another version,
attributed to Joos de Momper (1564–1624), was with H.
Jüngling in Scheveningen (1940); a third related scene set in
snow was with G. de Salvatore in Dijon (1961); and a fourth

painting is in a private collection (*Art et Curiosité* [1981]: 44–45, pl. 15). A version (oil on panel, 33 x 43 cm) was with the Alan Jacobs Gallery in London in 1984.

In the Detroit version, the path winding through the rocks at the lower left and across the bridge in the center is ambiguously rendered, showing misunderstandings in the logical flow of the path. These misunderstandings, if compared to the drawing in the Belgian private collection, strongly suggest that the version in Detroit is a copy, most likely based on the latter.

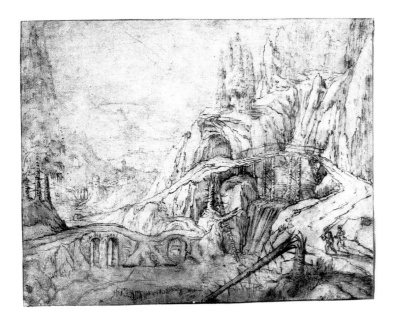

Copy after Marten de Vos

A15.
Holy Kinship, seventeenth century

Pen and brown ink over black chalk on discolored laid paper; 192 x 215 mm

WATERMARK: Obscured by lining

CONDITION: Solidly mounted on wove paper; foxing; surface grime; loss upper left corner, New York

PROVENANCE: John J. Peoli, New York, (purple collector's mark [L. 2020] on verso at lower center), sale, American Art Galleries, New York, May 8, 1894, no. 120b (as Annibale Carracci); James E. Scripps, Detroit, 1894

Gift of Mrs. James E. Scripps (1909.1 S-Dr. 52)

Graham Smith recognized (verbally) this drawing as a variant of the composition in a 1585 altarpiece by Marten de Vos (1532–1603) in the museum in Ghent, representing the *Holy Kinship* (Zweite 1980, no. 69, fig. 83). Although attributed to Annibale Carracci (1560–1609) while in the Peoli collection, in execution the drawing is closer to the draftsmanship of Jacob de Backer of Antwerp (ca. 1540/45–1591/1600) and Hendrick de Clerck of Brussels (ca. 1570–1629).

Copy after Sebastian Vrancx

A16.
Figure Seated under a Big Oak Tree (recto)
Soldiers Resting (verso)

Pen and brown ink and ocher, green, purple brown, blue,
and light red wash over a preliminary drawing in graphite
(recto), pen and brown ink and brown wash over a prelimin-
ary drawing in graphite (verso), on discolored laid paper;
209 x 307 mm

ANNOTATION: With pen and brown ink on verso at lower
right, *Velvet Bruegle*

CONDITION: Broken vertical crease along right edge;
repaired lower edge; small tears and losses; inlaid to wove
paper

PROVENANCE: Unidentified collector (black collector's
mark on verso in lower left corner); E. Peart, London (black
collector's mark [L. 891] on verso at lower left); Paul L.
Grigaut, Ann Arbor, Michigan

Founders Society Purchase, Robert H. Tannahill Founda-
tion Fund (1971.43)

This drawing shows the influence of Sebastian Vrancx
(1573–1647); the verso may actually be a copy of one of his
paintings.

Style of Anthony van Dyck

A17.
Three Double Portraits, ca. seventeenth/
eighteenth century

Black chalk, heightened with white, on blue laid paper;
irregular, 332 x 205 mm

ANNOTATIONS: With pen and brown ink on verso at upper
center, *for Mr. Rammee*; with pen and brown ink on verso
at lower center, *6-*

CONDITION: Discoloration; overall abrasion; creasing and
fold marks; inscription in corrosive ink bleeding through
from verso

PROVENANCE: E. Speelman, London

REFERENCE: Scheyer 1936, no. 69, ill. (as Van Dyck)

Founders Society Purchase, William H. Murphy Fund
(1934.117)

Although this drawing has been interpreted (e.g., by Ernst Scheyer) as a preliminary study by Anthony van Dyck (1599–1641) for the double portrait of *Philip Pembroke and his Sister* at Chatsworth (Glück 1931, p. 404), it more likely renders three separate portraits by an unidentified artist. In composition it reflects double portraits by Sir Peter Lely (1618–1680), such as *Sir Thomas and Lady Fanshawe* of ca. 1659 (Beckett 1951, no. 189, pl. 64). The unknown artist may have tried out three different arrangements for a double portrait that remains to be identified.

Justus Müller Hofstede suggested (verbally, 1975) the Flemish painter Gonzales Coques (1614–1684) as the author, while Horst Vey considered (verbally) the drawing to be a copy after double portraits perhaps by Van Dyck or a later artist. The drawing may be by an English follower of Van Dyck and date as late as the eighteenth century.

Attributed to Bonaventura Peeters
1614 Antwerp – Hoboken 1652

A18.
Fishermen Hauling in Fish, seventeenth century

Pen and brown ink, watercolor, black chalk, and blue, ocher, and red wash on buff laid paper; 163 x 297 mm

ANNOTATION: With pen and brown ink on verso at lower right, *Peters*

WATERMARK: Coat of arms with H-B (similar to Churchill 267, 267a, and Heawood 602, 603)

CONDITION: Surface grime; slight abrasion

PROVENANCE: Nathan Chaikin, New York, 1961; Mr. and Mrs. Bernard F. Walker, Bloomfield Hills, Michigan

REFERENCE: *BDIA* 1969: 18

Gift of Mr. and Mrs. Bernard F. Walker (1968.32)

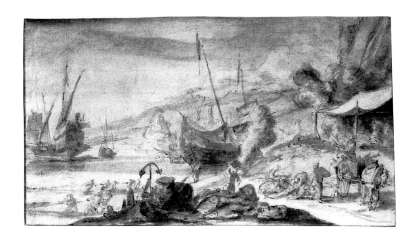

Although the subject matter is related to drawings by Bonaventura Peeters, the execution is different enough to list the sheet among the attributed works.

Circle of Peter Paul Rubens

A19.
River God

Black chalk, heightened with white, on light brown paper;
192 x 237 mm

CONDITION: Skinning at upper, center, and lower right;
some staining and accretions

PROVENANCE: William Bates, London (red collector's mark
[L. 2604] on recto at lower right), sale, Sotheby's, London,
January 19–21, 1887, under no. 337 (as Rubens); sale,
Sotheby's, London, March 1889; James E. Scripps, Detroit,
1889

Gift of Mrs. James E. Scripps (1909.1 S-Dr. 228)

In an annotation made on the mount in 1966, Michael Jaffé
attributed the drawing to Theodor van Thulden
(1606–1669), a collaborator with Rubens. While there exists
a certain similarity with the drawings in black chalk attrib-
uted to Van Thulden (see Béguin 1979, pp. 47–66, for the
most recent discussion of this group), it seems preferable
here to keep this study among the anonymous Rubens
followers.

Copy after Peter Paul Rubens

A20.
Samson Fighting the Lion

Black and red chalk, heightened with white, on discolored
laid paper; 206 x 278 mm

ANNOTATIONS: With pencil on verso at lower right, *David
& the Lion / or Hercules*; with pencil on verso at lower left,
Rubbens [*sic*]

CONDITION: Stains and accretions at edges and in image;
mat burn; foxing; tear right edge; small losses at lower edge
and upper right corner

PROVENANCE: James Northcote, London; William Bates,
London (red collector's mark [L. 2604] on recto in lower
right corner), sale, Sotheby's, London, January 19–21, 1887,
under no. 337 (as Rubens); sale, Sotheby's, London, March
1889; James E. Scripps, Detroit, 1889

REFERENCE: Los Angeles 1954, under no. 14

Gift of Mrs. James E. Scripps (1909.1 S-Dr. 229)

The pallid, flat appearance of the red chalk and the parallel
hatching that runs consistently from left to right indicates
that this may be a counterproof of a drawing based on a
Rubens composition of ca. 1615–17, known in a number
of painted, drawn, and etched versions (see Held 1980,
no. 311).

The drawing from which this counterproof was pulled
was not by Rubens. Its execution is too even and dry, the
parallel hatching too uniform, and there are no pentimenti.
The drawing was but a poor anonymous copy, most likely
after the painting in the Hernani collection (Madrid
1977–78, no. 79, color ill.), because the red cloth draped
around Samson's waist and right arm billows in folds iden-
tical to the ones in this version (this drapery is also indi-
cated in red chalk in the Detroit counterproof).

Copy after Peter Paul Rubens

A21.
Two Angels

Pen and brown ink on discolored laid paper; irregular, 88 x 254 mm

CONDITION: Cut from a larger sheet; solidly mounted; staining in image; accretions and surface grime; repaired losses at edges; small tears

PROVENANCE: W. Koenig, Vienna; Bishop John Török, Pittsburgh

REFERENCES: Stix and Leporini 1927, p. 26, no. 398 (as a Rubens study for *The Martyrdom of Saint Anthony of Egypt*); Leporini 1928, p. 134; *BDIA* 1944: 18, ill. (as Rubens); *BDIA* 1945: 54 (as Rubens)

Gift of Bishop John Török (1944.94)

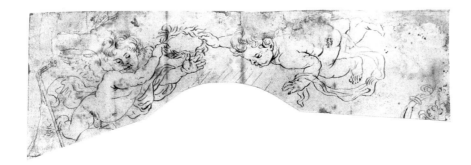

The Detroit drawing is not, as suggested by Stix and Leporini, an autograph study for the painting of ca. 1615 in the collection of Count Schönborn, Pommersfelden (Vlieghe 1972a, no. 64, fig. 113); rather, it is a copy of the two putti hovering over the dying Saint Anthony Abbot in that painting. The Detroit putti are cut from a drawing Leporini published as an original study by Rubens when it was in the Havelsky collection in Brno (1928). The lower section of the drawing is now in the Sammlung Wichert, Kurland Museum, Essen (letter to the author, February 13, 1987). Vlieghe also correctly listed the latter drawing as a copy after Rubens's painting in Pommersfelden.

Unknown Flemish Artist (?)

A22.
Head of a Man Facing Right, seventeenth/
eighteenth century

Black chalk, heightened with white, on blue paper;
209 x 146 mm

ANNOTATION: With pencil on verso at lower left, *D. 1388.*
[in circle]

CONDITION: Solidly mounted; repaired upper and lower
right corners; creasing through image area

PROVENANCE: E. Parsons & Sons, London, sales cat. 46,
no. 263 (as Van Dyck)

Founders Society Purchase, Octavia W. Bates Fund
(1934.119)

The attribution to the school of Rubens under which this
drawing was accessioned needs further proof; the drawing
may be of Italian origin.

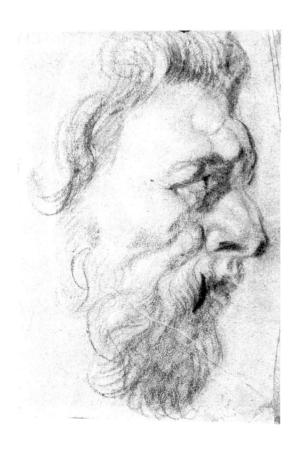

Bibliography

Amsterdam 1935
Amsterdam, Museum Fodor. *Teekeningen van oude meesters behoorende tot de verzameling van Mr. Chr. P. van Eeghen.* Exh. cat., 1935.

Amsterdam 1958
Amsterdam, Rijksmuseum, Prentenkabinet. *De Verzameling van Mr Chr. P. Van Eeghen.* Exh. cat. by L. C. J. Frerichs, 1958.

Amsterdam 1975–76
Amsterdam, Rijksmuseum, Prentenkabinet. *De Verzameling van H. van Leeuwen.* Exh. cat. by Pieter Schatborn, 1975–76.

Amsterdam 1976
Amsterdam, Rijksmuseum. *All the Paintings of the Rijksmuseum in Amsterdam: A Completely Illustrated Catalogue.* Coll. cat. by Pieter J. J. van Thiel et al., 1976.

Amsterdam 1976a
Amsterdam, Rijksmuseum. *Tot Lering en vermaak: betekenissen van Hollandse genrevoorstellingen uit de zeventiende eeuw.* Exh. cat. by E. de Jongh, 1976.

Amsterdam 1978
Amsterdam, Rijksmuseum. *Netherlandish Drawings of the Fifteenth and Sixteenth Centuries. Catalogue of the Dutch and Flemish Drawings in the Rijksmuseum (Amsterdam).* 2 vols. Coll. cat. by K. G. Boon, 1978.

Antwerp 1938
Antwerp, Cabinet des Estampes de la Ville d'Anvers, Musée Plantin-Moretus. *Catalogue des Dessins Anciens: Écoles Flamande et Hollandaise.* 2 vols. Coll. cat. by A. J. J. Delen, 1938.

Art News 1939
Art News 38, no. 10 (December 9, 1939): 14, ill.

BDIA 1935
"Accessions: January 1, 1934, to December 31, 1934: Drawings." *Bulletin of the Detroit Institute of Arts* (Annual Report) 14, no. 5 (1935): 57.

BDIA 1938
"Accessions: Drawings." *Bulletin of the Detroit Institute of Arts* (Annual Report) 17, no. 5 (1938): 40.

BDIA 1939
"Accessions: January 1, 1938, to December 31, 1938: Drawings." *Bulletin of the Detroit Institute of Arts* (Annual Report) 18, no. 5 (1939): 11.

BDIA 1941
"Accessions: January 1, 1940, to December 31, 1940: Drawings and Prints." *Bulletin of the Detroit Institute of Arts* (Annual Report) 20, no. 5 (1941): 47.

BDIA 1944
Parenthetical note after "The Penitent Saint Peter by Jacob Jordaens" by W. R. Valentiner. *Bulletin of the Detroit Institute of Arts* 24, no. 2 (1944): 18.

BDIA 1945
"Accessions: January 1, 1944, to December 31, 1944: Drawings and Prints." *Bulletin of the Detroit Institute of Arts* (Annual Report) 24, no. 4 (1945): 54.

BDIA 1947
"Accessions: January 1, 1946, to December 31, 1946: Drawings." *Bulletin of the Detroit Institute of Arts* (Annual Report) 26, no. 2 (1947): 45.

BDIA 1950/51
"Accessions: January 1, 1950, to December 31, 1950: Drawings." *Bulletin of the Detroit Institute of Arts* (Annual Report) 30, no. 2 (1950/51): 52.

BDIA 1956/57
"Accessions: January 1, 1956, to December 31, 1956: Drawings." *Bulletin of the Detroit Institute of Arts* (Annual Report) 36, no. 2 (1956/57): 51.

BDIA 1959/60
"J. Accessions: January 1, 1959, to December 31, 1959: Drawings." *Bulletin of the Detroit Institute of Arts* (Annual Report) 39, no. 2 (1959/60): 44.

BDIA 1962
"L. Accessions: January 1 to December 31, 1961: Drawings." *Bulletin of the Detroit Institute of Arts* (Annual Report) 41, no. 2 (Winter 1962): 32.

BDIA 1965
"Catalogue of Paintings, Sculpture, Prints and Drawings in the Kamperman Gift." *Bulletin of the Detroit Institute of Arts* 44, no. 1 (1965): 17.

BDIA 1969
"Appendix VII: Accessions, January 1 to December 31, 1968: Drawings." *Bulletin of the Detroit Institute of Arts* 48, no. 1 (1969): 17–18.

BDIA 1978/79
"Gifts and Purchases: Drawings and Watercolors: Dutch." *Bulletin of the Detroit Institute of Arts* 57, no. 4 (1978/79): 162–163.

Beck 1972–73
Beck, Hans-Ulrich. *Jan van Goyen, 1596–1656.* 2 vols. Amsterdam, 1972–73.

Beckett 1951
Beckett, R. B. *Lely.* London, [1951].

Béguin 1979
Béguin, Sylvie. "La Galerie du Connetable de Montmorency à l'Hôtel de Rue Sainte-Avoye. Le Décor de Nicolò Dell'Abate." *Bulletin de la Société de l'Histoire de l'Art Français* (Année 1977, published 1979): 47–66.

Benesch 1943
Benesch, Otto. "The Name of the Master of the Half Lengths." *Gazette des Beaux-Arts* 6th ser., 23, no. 1 (January-June 1943): 269–282. Reprint. Benesch. *Collected Writings.* Vol. 2. London and New York, 1971.

Bergsträsser 1979
Bergsträsser, Gisela. *Niederländische Zeichnungen, 16. Jahrhundert, im Hessischen Landesmuseum Darmstadt.* Darmstadt, 1979.

Berlin 1974
Berlin, Staatliche Museen Preussischer Kulturbesitz, Kupferstichkabinett. *Die holländische Landschaftzeichnung 1600–1740: Hauptwerke aus dem Berliner Kupferstichkabinett.* Exh. cat. by Wolfgang Schulz, 1974.

Berlin 1975
Berlin, Staatliche Museen Preussischer Kulturbesitz, Kupferstichkabinett. *Pieter Bruegel d. Ä. als Zeichner: Herkunft und Nachfolge.* Exh. cat. by Hans Mielke et al., 1975.

Bernt 1957–58
Bernt, Walther. *Die niederländischen Zeichner des 17. Jahrhunderts.* 2 vols. Munich, 1957–58.

Bock and Rosenberg 1930
Bock, Elfried, and Jakob Rosenberg, eds. *Staatliche Museen zu Berlin. Die Zeichnungen alter Meister im Kupferstichkabinett. Die niederländischen Meister.* 2 vols. Edited by Max J. Friedländer. Frankfort on the Main, 1930.

Briquet
Briquet, Charles Moïse. *Les Filigranes: dictionnaire historique des marques du papier, dès leur apparition vers 1282 jûsqu'en 1600. . . .* 4 vols. 2nd ed. Leipzig, 1923. Reprint. Hildesheim and New York, 1977.

Broos 1981
Broos, Ben. *Rembrandt en tekenaars uit zijn omgeving, Oude tekeningen . . . collectie Fodor.* Amsterdam, 1981.

De Bruijn Kops 1982
De Bruijn Kops, C. J. "De Gedaanteverandering van het geschilderde plafond door Jacob de Wit in de voorzaal van het K. O. G. Rijksmuseum, Amsterdam." (Koninklijk Oudheidkundig Genootschap) *Jaarverslagen* (1982): 53–59.

Brunswick 1976
Brunswick, Herzog Anton Ulrich-Museum. *Verzeichnis der Gemälde vor 1800.* Coll. cat. by Sabine Jacob and Rüdiger Klessmann, 1976.

Brussels 1983
Brussels, Société Générale de Banque et L'A.S.B.L. Les Amis du Dessin. *Dessins du XVᵉ au XVIIIᵉ Siècle dans les collections privées de Belgique.* Exh. cat., 1983.

Cambridge 1980
Cambridge, Mass., Harvard University, Houghton Library. *Drawings for Book Illustration. The Hofer Collection.* Exh. cat. by David P. Becker, 1980.

Cavalli-Björkman 1977
Cavalli-Björkman, Görel. *Rubens i Sverige.* Stockholm, 1977.

Churchill
Churchill, W. A. *Watermarks in Paper in Holland, England, France, etc., in the XVII and XVIII Centuries and their Interconnection.* Amsterdam, 1935. Reprint. Amsterdam, 1965.

Cleves 1979
Cleves, Städtisches Museum, Haus Koekkoek. *Soweit der Erdkreis reicht: Johann Moritz von Nassau-Siegen, 1604–1679.* Exh. cat., 1979.

Cleves 1980
Cleves, Städtisches Museum, Haus Koekkoek. *Jan de Beijer (1703–1780): Zeichnungen Von Emmerich bis Roermond.* Exh. cat. compiled by Guido de Werd, 1980.

Coburg 1970
Coburg, Kunstsammlungen der Veste Coburg. *Ausgewählte Handzeichnungen von 100 Künstlern aus fünf Jahrhunderten, 15.–19. Jahrhundert.* Exh. cat. edited by Heino Maedebach, 1970.

Dattenberg 1967
Dattenberg, Heinrich. *Niederrheinansichten holländischer Künstler des 17. Jahrhunderts.* Düsseldorf, 1967.

Detroit 1949
The Detroit Institute of Arts. *Fifty Drawings from the Collection of John S. Newberry.* Exh. cat., 1949.

Detroit 1965
The Detroit Institute of Arts. *The John S. Newberry Collection.* Exh. cat., 1965.

Detroit 1967
The Detroit Institute of Arts. *Paintings in the Detroit Institute of Arts: Checklist of Paintings Acquired Before January, 1967.* 2nd ed. 1967.

Detroit 1984
The Detroit Institute of Arts. *Voyages Pittoresques: European Scenes in Prints and Drawings from the Permanent Collection.* Exh. cat. by Marilyn F. Symmes, 1984.

Dordrecht 1968
Dordrechts Museum. *Nederlandse Tekeningen der Zestiende en Zeventiende Eeuw.* Exh. cat., 1968.

Düsseldorf 1968
Düsseldorf, Städtische Kunsthalle. *Niederländische Handzeichnungen 1500–1800 aus dem Kunstmuseum Düsseldorf.* Exh. cat. by Eckhard Schaar, 1968.

Van Eeghen and Van der Kellen 1905
Van Eeghen, P., and J. Ph. van der Kellen. *Het werk van Jan en Casper Luyken.* 2 vols. Amsterdam, 1905.

Eisler 1924
Eisler, Max. *Josef Israëls.* London, 1924.

Eisler 1976
Eisler, Colin T. *Flemish and Dutch Drawings from the Fifteenth to the Eighteenth Century.* Boston and Toronto, 1976.

Elias 1905
Elias, J. E. *De Vroedschap van Amsterdam, 1578–1795.* Vol. 2. Haarlem, 1905.

Foucart and Lacambre 1978
Foucart, Jacques, and Jean Lacambre. "Grands tableaux d'autel flamands inédits ou peu connus, conservés en France." *La revue du Louvre* 28, no. 1 (1978): 6–11.

Franz 1969
Franz, Heinrich Gerhard. *Niederländische Landschaftsmalerei im Zeitalter des Manierismus.* 2 vols. Graz, 1969.

Gabriels 1930
Gabriels, Juliane. *Artus Quellien, de oude "Kunstryck belthouwer."* Antwerp, 1930.

Van Gelder 1970
Van Gelder, J. G. "Lambert ten Kate als Kunstverzamelaar." *Nederlands Kunsthistorisch Jaarboek* 21 (1970): 139–186.

Van Gelder and Jost 1985
Van Gelder, J. G., and Ingrid Jost. *Jan de Bisschop and his Icones & Paradigmata, Classical Antiquities and Italian Drawings for Artistic Instruction in Seventeenth Century Holland.* Edited by Keith Andrews. Doornspijk, 1985.

Gerson 1936
Gerson, Horst. *Philips Koninck.* Berlin, 1936.

Giltay 1980
Giltay, J. "De tekeningen van Jacob van Ruisdael" (with English translation) *Oud-Holland* 94, nos. 2–3 (1980): 141–208.

Glück 1931
Glück, Gustav, ed. *Van Dyck, Des Meisters Gemälde.* Vol. 13 of *Klassiker der Kunst.* 2nd ed. Stuttgart and Berlin, 1931.

Gorissen 1964
Gorissen, Friedrich. *Conspectus Cliviae. Die klevische Residenz in der Kunst des 17. Jahrhunderts.* Cleves, 1964.

Grosse 1925
Grosse, Rolph. *Die Holländische Landschaftskunst, 1600–1650.* Stuttgart, 1925.

The Hague 1977
The Hague, Mauritshuis. *Mauritshuis: The Royal Cabinet of Paintings Illustrated General Catalogue.* Coll. cat., 1977.

Hamburg 1965
Hamburg, Kunsthalle. *Zeichnungen alter Meister aus deutschem Privatbesitz.* Exh. cat., 1965.

Hanover and Hartford 1973
Hanover, Dartmouth College, Hopkins Center Art Galleries, and Hartford, Conn., Wadsworth Atheneum. *One Hundred Master Drawings from New England Private Collections*. Exh. cat. by Franklin W. Robinson, 1973.

Heawood
Heawood, Edward. *Watermarks, Mainly of the Seventeenth and Eighteenth Centuries*. Vol. 1 of *Monumenta Chartae Papyraceae Historiam Illustrantia: or Collection of Works and Documents Illustrating the History of Paper*. Edited by E. J. Labarre. Hilversum, Holland, 1950.

Hefting 1975
Hefting, Victorine. *Jongkind, sa vie, son oeuvre, son époque*. Paris, 1975.

Heil 1931
Heil, Walter. "Some French Drawings of the Nineteenth Century." *Bulletin of the Detroit Institute of Arts* 12, no. 4 (1931): 37–41.

Held 1933
Held, Julius S. "Notizen zu einem niederländischen Skizzenbuch in Berlin." *Oud-Holland* 50 (1933): 273–288.

Held 1964
Held, Julius S. *Rembrandt and the Book of Tobit*. Vol. 2 of *Gehenna Essays in Art*. Northampton, Mass., 1964.

Held 1971
Held, Julius S. "The Last of the 'Attic Nights': A Drawing by Jan Goeree." *Master Drawings* 9, no. 1 (1971): 51–54.

Held 1980
Held, Julius S. *The Oil Sketches by Peter Paul Rubens*. 2 vols. Princeton, 1980.

Hofstede de Groot 1907–28
Hofstede de Groot, Cornelis. *Beschreibendes und kritisches Verzeichnis der Werke der hervorragendsten holländischen Maler des XVII. Jahrhunderts*. Erlingen and Paris, 1907–28.

Holland 1982
Holland, Michigan, Hope College, De Pree Art Center and Gallery. "Dutch Art and Modern Life." No cat. 1982.

Hollstein 1949–
Hollstein, F. W. H. *Dutch and Flemish Etchings, Engravings and Woodcuts, ca. 1450–1700*. 28 vols. to date. Amsterdam, 1949–.

Houbraken 1718–21
Houbraken, Arnold. *Grosse Schouburgh der Niederländischen Maler und Malerinnen*. Translated by Alfred von Wurzbach. Vienna, 1880. Originally published as *De groote schouburgh der nederlantsche konstschilders en schilderessen . . .* (Amsterdam, 1718–21).

Judson 1973
Judson, J. Richard. *The Drawings of Jacob de Gheyn II*. New York, 1973.

Keyes 1984
Keyes, George S. *Esaias van den Velde 1587–1630*. Vol. 4 of *Monographs on Dutch and Flemish Paintings*. Doornspijk, 1984.

Knab 1964
Knab, Eckhart. Notes: "Willem Romeijn, 'Een gesicht van Tivoli naer Romen.'" *Master Drawings* 2, no. 2 (1964): 163–168.

Knuttel 1962
Knuttel, Gerhardus. *Adriaen Brouwer, the Master and his Work*. The Hague, 1962.

Koegler 1930
Koegler, Hans. "Einiges über David Joris als Künstler." *Oeffentliche Kunstsammlung Basel, Jahresberichte 1928–1930* n.s. 25–27 (1930): 157–201.

Labarre
See Heawood

Laureyssens 1966
Laureyssens, Willy. "Hendrik De Clercks triptiek uit de Kapellekerk te Brussel." *Bulletin des Musées Royaux des Beaux-Arts de Belgique* 15, no. 3 (1966): 165–176.

Leach and Morse 1978
Leach, Mark Carter, and Peter Morse, eds. *Netherlandish Artists*. Vol.2 of *The Illustrated Bartsch*. Edited by Walter L. Strauss. New York, 1978.

Lees 1913
Lees, Frederic. *The Art of the Great Masters as Exemplified by Drawings in the Collection of Emile Wauters*. London, 1913.

Leningrad 1958
Leningrad, Hermitage. *Catalogue of Paintings* (in Russian). Vol. 2. 1958. Reprint. 1981.

Leporini 1928
Leporini, Heinrich. "A Hitherto Unknown Drawing by Rubens." *The Burlington Magazine* 53, no. 156 (September 1928): 134–139.

Lesley 1939
Lesley, Parker. "The Growth of the Collection of Drawings." *Bulletin of the Detroit Institute of Arts* 18, no. 7 (April 1939): 3–6.

Lindeman 1929
Lindeman, C. M. A. A. *Joachim Anthonisz. Wtewael.* Utrecht, 1929.

Logan 1971
Logan, Anne-Marie. "Review of Exhibition Catalogue 'Dutch Mannerism. Apogee and Epilogue.'" *Master Drawings* 9, no. 3 (1971): 276–280.

Logan 1983
Logan, Anne-Marie. Review of "Ben Broos, 'Oude tekeningen in het bezit van de Gemeentemusea van Amsterdam waaronder de collectie Fodor: Rembrandt en tekenaars uit zijn omgeving.'" *Master Drawings* 21, no. 2 (1983): 175–176.

Logan 1984
Logan, Anne-Marie. Review of "Bernhard Schnackenburg, 'Adriaen van Ostade. Isack van Ostade. Zeichnungen und Aquarelle.'" *Master Drawings* 22, no. 1 (1984): 80–82.

London 1874
London, Science and Art Department of the Committee of Council on Education, South Kensington Museum [Victoria and Albert Museum]. *Dyce Collection. A Catalogue of the Paintings, Miniatures, Drawings, Engravings, Rings, and Miscellaneous Objects Bequeathed by the Reverend Alexander Dyce.* Coll. cat. by George William Reid, Samuel Redgrave, and Charles C. Black, 1874.

London 1915–32
London, British Museum. *Catalogue of Drawings by Dutch and Flemish Artists Preserved in the Department of Prints and Drawings in the British Museum.* 5 vols. Coll. cat. by Arthur M. Hind, 1915–32.

London 1970
London, National Gallery. *The Flemish School, circa 1600–circa 1900.* National Gallery Catalogues. Coll. cat. by Gregory Martin, 1970.

London 1973
London, National Gallery. *Illustrated General Catalogue.* Coll. cat., 1973.

Los Angeles 1954
Los Angeles County Museum of Art. *A Catalogue of Flemish, German, Dutch and English Paintings, XV–XVIII Century.* Vol. 2. Coll. cat. by Paul Wescher, 1954.

Lowenthal 1986
Lowenthal, Anne Walter. *Joachim Wtewael and Dutch Mannerism.* Doornspijk, 1986.

Lugt
Lugt, Frits. *Les Marques de collections de dessins et d'estampes. . . .* Amsterdam, 1921. *Supplément.* The Hague, 1956.

Lugt 1931
Lugt, Frits. "Beiträge zu dem Katalog der Niederländischen Handzeichnungen in Berlin." *Jahrbuch der preussischen Kunstsammlungen* 52 (1931): 36–80.

Madrid 1977–78
Madrid, Palacio de Velázquez. *Pedro Pablo Rubens.* Exh. cat. by Matías Díaz Padrón, 1977–78.

Van Mander 1604
Van Mander, Karel. *Het Schilder-Boeck: waerin Voor eerst de leerlustighe Ieught den grondt der Eded Vry SCHILDERCONST in Verscheyden deelen Wort Voorghedraghen.* Haarlem, 1604. Reprint. Amsterdam, 1943.

Mielke 1979
Mielke, Hans. "Radierer um Bruegel." In *Pieter Bruegel und seine Welt.* Edited by Otto von Simson and Matthias Winner. Berlin, 1979.

Minneapolis 1961
Minneapolis, University of Minnesota, University Gallery. *The Eighteenth Century: One Hundred Drawings by One Hundred Artists.* Exh. cat., 1961.

Minneapolis 1971
Minneapolis Institute of Arts. *Dutch Masterpieces from the Eighteenth Century: Paintings & Drawings 1700–1800.* Exh. cat. by Earl Roger Mandle, 1971.

Montreal 1944
Montreal Art Association. "Five Centuries of Dutch Art." No cat. 1944.

Moreau-Nélaton 1918
Moreau-Nélaton, Etienne. *Jongkind raconté par lui-même*. Paris, 1918.

De Morinni 1956
De Morinni, Clara More. "Cornelis Troost." *Antiques* 69, no. 1 (January 1956): 52–54.

Munich 1973
Munich, Staatliche Graphische Sammlung. *Die niederländischen Handzeichnungen des 15.–18. Jahrhunderts*. 2 vols. Coll. cat. by Wolfgang Wegner, 1973.

Münster 1974
Münster, Landesmuseum für Kunst und Kulturgeschichte. *Gerard Ter Borch: Zwolle 1617, Deventer 1681*. Exh. cat., 1974.

Newberry 1946
Newberry, John S., Jr. " 'The Fishing Party' by Cornelis Troost." *Bulletin of the Detroit Institute of Arts* 25, no. 1 (1946): 18.

New York 1889
New York, Frederick Keppel and Co. *Catalogue of an Exhibition of Drawings and Water Colors by Storm van 's Gravesande together with his Etchings Executed since 1884*. Exh. cat. with an introduction by Richard A. Rice, 1889.

New York 1979–80
New York, Pierpont Morgan Library. *Rubens and Rembrandt in their Century: Flemish & Dutch Drawings of the 17th Century from the Pierpont Morgan Library* (circulated to Paris, Antwerp, and London). Exh. cat. by Felice Stampfle, 1979–80.

New York and Paris 1977–78
New York, Pierpont Morgan Library, and Paris, Institut Néerlandais. *Rembrandt and His Century: Dutch Drawings of the Seventeenth Century*. Exh. cat. by Carlos van Hasselt, 1977–78.

Niemeijer 1973
Niemeijer, J. W. *Cornelis Troost 1696–1750*. Assen, 1973.

Northampton and Williamstown 1976–77
Northampton, Mass., Smith College Museum of Art, and Williamstown, Mass., Sterling and Francine Clark Art Institute. *Jongkind and the Pre-Impressionists: Painters of the École Saint-Siméon*. Exh. cat. by Charles C. Cunningham with Susan D. Peters and Kathleen Zimmerer, 1976–77.

Paris 1929–33
Paris, Musée du Louvre. *Inventaire général des dessins des Écoles du Nord, École Hollandaise*. 3 vols. Coll. cat. by Frits Lugt, 1929–33.

Paris 1950
Paris, École Nationale Supérieure des Beaux-Arts. *Inventaire général des dessins des Écoles du Nord, École Hollandaise*. 2 vols. Coll. cat. by Frits Lugt, 1950.

Paris 1968
Paris, Musée du Louvre. *Musée du Louvre, Inventaire général des dessins des écoles du Nord: Maîtres des anciens Pays-Bas nés avant 1550*. Coll. cat. by Frits Lugt, 1968.

Paris 1968–69
Paris, Institut Néerlandais. *Dessins de Paysagistes Hollandais du XVIIe Siècle de la Collection Particulière Conservée à l'Institut Néerlandais de Paris* (circulated to Brussels, Rotterdam, and Bern). 2 vols. Exh. cat. by Carlos van Hasselt, 1968–69.

Paris 1981
Paris, Institut Néerlandais. *Le monde paysan d'Adriaen et Isack van Ostade*. Exh. cat., 1981.

Paris 1983
Paris, Grand Palais. *L'Ecole de La Haye*. Exh. cat., 1983.

Poughkeepsie 1970
Poughkeepsie, New York, Vassar College Art Gallery. *Dutch Mannerism: Apogee and Epilogue*. Exh. cat. by Wolfgang Stechow, 1970.

Van Regteren Altena 1926
Van Regteren Altena, J. Q. "Cornelis Symonsz. van der Schalcke." *Oud-Holland* 43 (1926): 49–60.

Van Regteren Altena 1983
Van Regteren Altena, J. Q. *Jacques de Gheyn. Three Generations*. 3 vols. The Hague, Boston, and London, 1983.

Reinsch 1967
Reinsch, Adelheid. *Die Zeichnungen des Marten de Vos.* Bamberg, 1967.

Richardson 1939
Richardson, E. P. "The Landscape of Jan van Goyen." *Bulletin of the Detroit Institute of Arts* 19, no. 2 (1939): 12–17.

Richardson 1940
Richardson, E. P. "The Romantic Prelude to Dutch Realism." *The Art Quarterly* 111 (1940): 40–79.

Romers 1969
Romers, H. *J. de Beijer Oeuvre-catalogus.* The Hague, 1969.

Rosenberg 1928
Rosenberg, Jakob. *Jacob van Ruisdael.* Berlin, 1928.

Röthlisberger 1969
Röthlisberger, Marcel. *Bartholomäus Breenbergh, Handzeichnungen.* Berlin, 1969.

Scheyer 1936
Scheyer, Ernst. *Drawings and Miniatures from the XII. to the XX. Century.* Detroit, 1936.

Schnackenburg 1981
Schnackenburg, Bernhard. *Adriaen van Ostade, Isack van Ostade: Zeichnungen und Aquarelle.* 2 vols. Hamburg, 1981.

Schulz 1974
Schulz, Wolfgang. *Lambert Doomer: Sämtliche Zeichnungen.* Berlin and New York, 1974.

Schulz 1978
Schulz, Wolfgang. *Cornelis Saftleven 1607–1681: Leben und Werke.* Berlin and New York, 1978.

Schwerin 1882
Schwerin, Grossherzogliches Museum and Grossherzogliche Kunstsammlungen. *Beschreibendes Verzeichniss der Werke älterer Meister in der Grossherzoglichen Gemälde-Gallerie zu Schwerin.* Coll. cat. by Friedrich Schlie, 1882.

Schwerin 1982
Schwerin, Staatliches Museum. *Holländische und flämische Malerei des 17. Jahrhunderts.* Vol. 1. Coll. cat., 1982.

Slatkin 1976
Slatkin, Regina Shoolman. "Abraham Bloemaert and François Boucher: Affinity and Relationship." *Master Drawings* 14, no. 3 (1976): 247–260.

Spicer 1979
Spicer, Joaneath. "The Drawings of Roelandt Savery." Ph.D. diss., Yale University, New Haven, Conn., 1979.

Stampfle 1959
Stampfle, Felice. "An Early Drawing by Jacob van Ruisdael." *The Art Quarterly* 22, no. 2 (Summer 1959): 161–163.

Staring 1958
Staring, Adolph. *Jacob de Wit 1695–1754.* Amsterdam, 1958.

Staring 1959
Staring, Adolph. "Een vergissing van Jacob de Wit." *Oud-Holland* 74, no. 1 (1959): 56–58.

Stechow 1966
Stechow, Wolfgang. *Dutch Landscape Painting of the Seventeenth Century.* London, 1966.

Stechow 1975
Stechow, Wolfgang. *Salomon van Ruysdael.* Berlin, 1975.

Stix and Leporini 1927
Stix, Alfred, and Heinrich Leporini. *Die Handzeichnungen der Sammlung Török.* Vienna, 1927.

Strauss 1977
Strauss, Walter L., ed. *Hendrik Goltzius, 1558–1617: The Complete Engravings and Woodcuts.* 2 vols. New York, 1977.

Sumowski 1980–
Sumowski, Werner. *Drawings of the Rembrandt School.* 9 vols. to date. Edited and translated by Walter L. Strauss. New York, 1980–.

Sutton 1980
Sutton, Peter Campbell. *Pieter de Hooch: Complete Edition, with a Catalogue Raisonné.* Ithaca, New York, 1980.

Thieme and Becker 1907–50
Thieme, Ulrich, and Felix Becker. *Allgemeines Lexikon der Bildenden Künstler von der Antike bis zur Gegenwart.* 37 vols. Leipzig, 1907–50.

Utrecht 1963
Utrecht, Centraal Museum. *Nederlandse tekeningen der zestiende en zeventiende eeuw . . . uit de Collectie Paul Brandt, Amsterdam.* Exh. cat., 1963.

Valentiner 1934
Valentiner, W. R. "A Painting by Jan van Scorel and a Drawing by David Joris." *Bulletin of the Detroit Institute of Arts* 14, no. 1 (1934): 2–7.

Verbeek 1957
Verbeek, Albert. *Die Niederrheinansichten Jan de Beyers.* Supplement 5 of *Die Kunstdenkmäler des Rheinlands.* Edited by Walther Zimmermann. Essen, 1957.

Vienna 1928
Vienna, Graphische Sammlung Albertina. *Die Zeichnungen der Niederländischen Schulen des XV. und XVI. Jahrhunderts.* Vol. 2 of *Beschreibender Katalog der Handzeichnungen in der Graphischen Sammlung Albertina.* Coll. cat. by Otto Benesch. Series edited by Alfred Stix, 1928.

Vlieghe 1972
Vlieghe, Hans. *Saints I.* Vol. 8 of *Corpus Rubenianum Ludwig Burchard.* Brussels, 1972.

Vlieghe 1972a
Vlieghe, Hans. *Gaspar de Crayer, Sa vie et ses oeuvres.* 2 vols. Brussels, 1972.

Wegner and Pée 1980
Wegner, Wolfgang, and Herbert Pée. "Die Zeichnungen des David Vinckboons." *Münchner Jahrbuch der bildenden Kunst* 3rd ser., no. 31 (1980): 35–128.

Weigel 1861
Weigel, Rudolph. *Handzeichnungen berühmter Meister aus der Weigel'schen Kunstsammlung.* Leipzig, 1861.

White 1964
White, Christopher. *The Flower Drawings of Jan van Huysum.* Leigh-on-sea, 1964.

Winnipeg 1952
Winnipeg Art Gallery. "Treasures of Old Masters." No cat. 1952.

Zweite 1980
Zweite, Armin. *Marten de Vos als Maler.* Berlin, 1980.

Zwollo 1965
Zwollo, An. "De Landschaptekeningen van Cornelis Massys." *Nederlands Kunsthistorisch Jaarboek* 16 (1965): 43–65.

Index of Accession Numbers

Numbers in italics refer to pages upon which color plates appear.

General Index

Note: All numbers refer to pages and not to catalogue numbers. Those in boldface refer to pages on which color plates are to be found, and those in italics refer to black and white illustrations.